Tony Oursler
Works 1997–2007

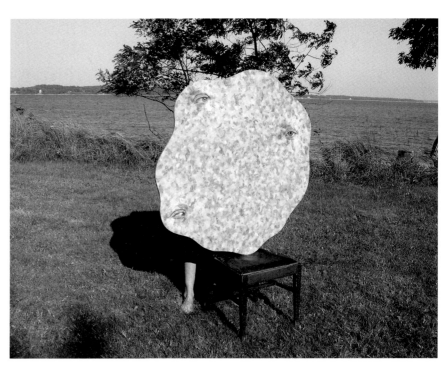

Polymorph-Green, 2004
Acrylic and collage on panel

Table of Contents

I

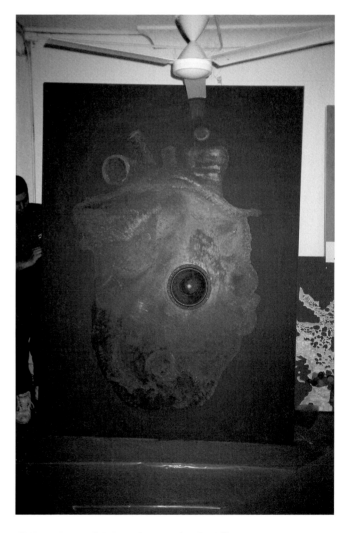

The Poetics Project—Why I Love Drums (with Mike Kelley), 1997
Acrylic, glitter, and speaker on wood panel

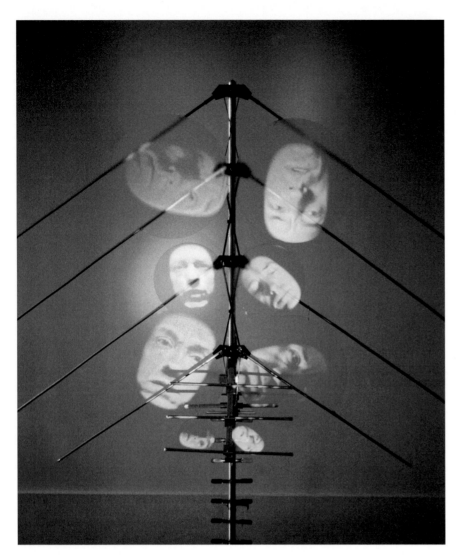

Electric Blue, 2002
Sony VPL-CS4 projector, DVD player, antenna, Plexiglas disc, DVD
Performance by Joe Gibbons

Camera Remote, 2002
Acrylic on paper

Anti, 2002
Acrylic on paper

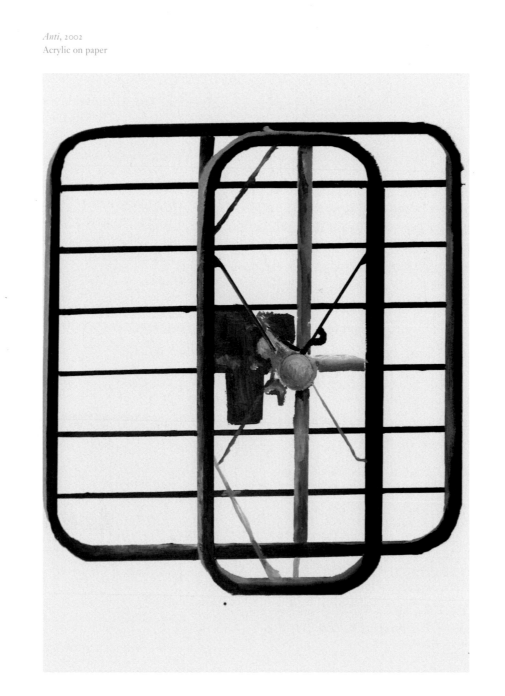

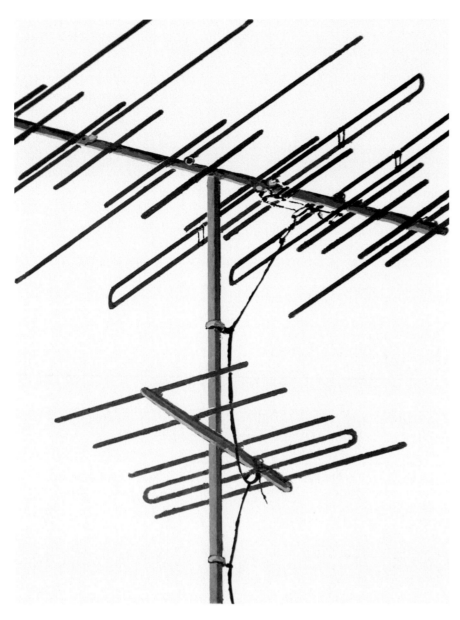

Untitled, 2001
Acrylic on paper

Mediumud, 2001
Acrylic on paper

The Darkest Color Infinitely Amplified, 2000
Video installation

Friends, Friends, Friends, 2002
Acrylic on paper

10

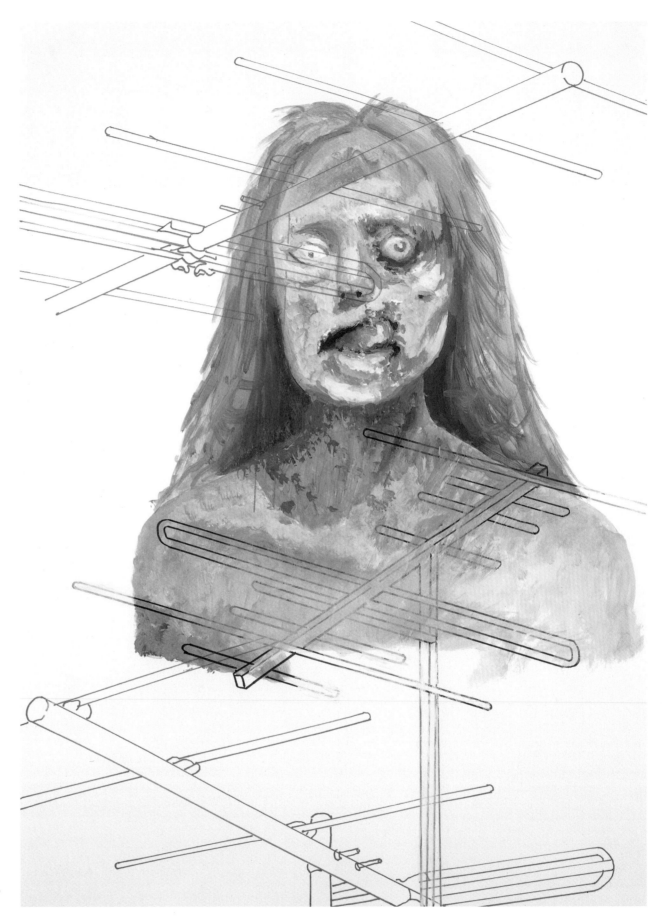

Horror Harmonies, 2000
Acrylic on paper

Disk (Deep Blue), 2002
Acrylic on paper

Disk (Maxout), 2002
Acrylic on paper

Disk (Hidden), 2002
Acrylic on paper

DVD (Wrong), 2002
Acrylic on paper

Ride, 2002
Video, 20' 3" (loop)

Power Pole, 2002
Acrylic and fabric on paper

Double Blind, 2000
Acrylic on paper

Kircher's Actor, 2000
Acrylic on paper

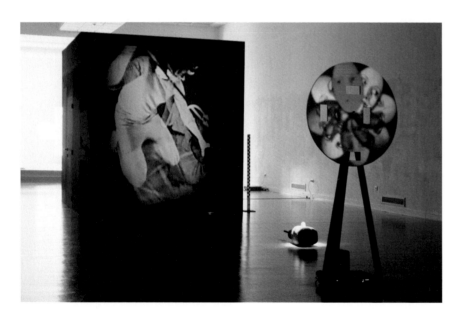

Optics, 1999
Mixed media installation with video projection

FIG. 23-10. Enlarged structure of domain VI of Fig. 23-9 using the numbering of type 3▪▪▪▪▪▪▪ Types 1 and 2 have three additional bases in the 5' noncoding region before this sequence. The bases implicated in attenuation of type 1 (→), type 2 (→), and type 3 (→) ▪▪▪▪ strains are shown.

He is blinded by bright ... facing him. He cannot see ... leton at the side, which is ... kness. Its position also ... it from him, as well as ... he spectators. When the ... on the man are suddenly ... off and th... n turne... t, the ... to th... e inst... n, the ... eleton ... aware... audienc... othing.

Click (Shutter), 1998
Acrylic on paper

Gothic (sic), 2001
Acrylic on paper

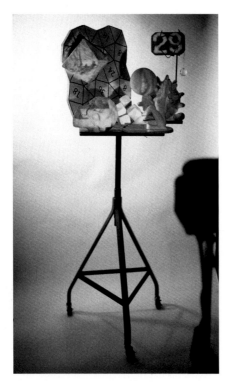

Actions Speak Louder than Images, 1997
Mixed media, video installation

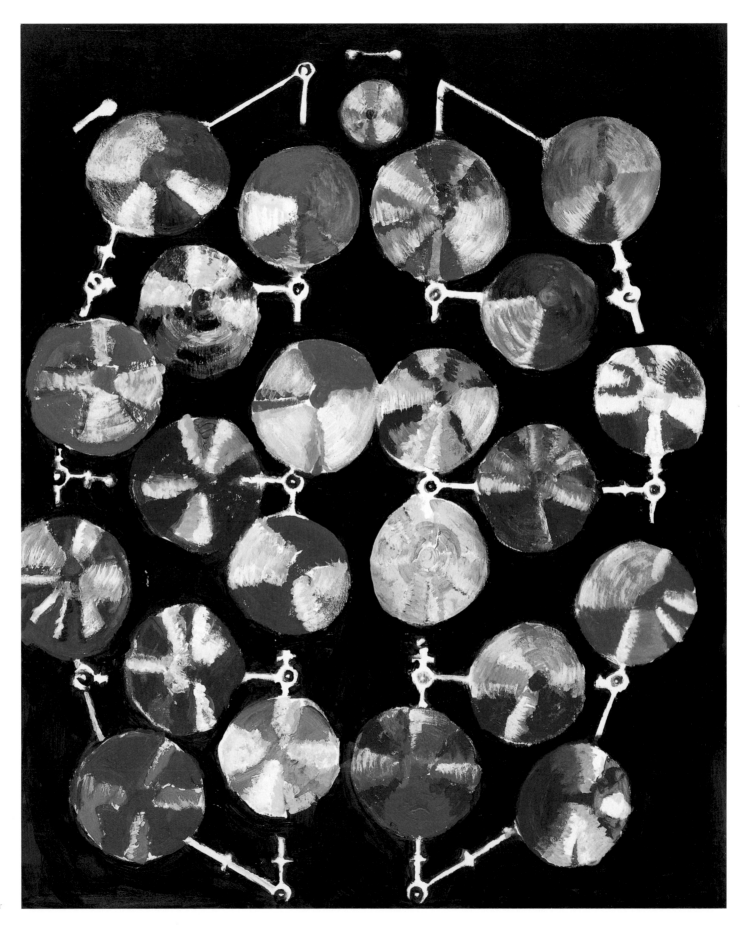

Pickup, 2002
Acrylic on paper

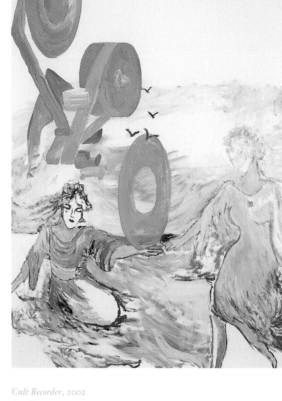

Cult Recorder, 2002
Acrylic on paper

Tracer, 2001-2002
Acrylic on paper

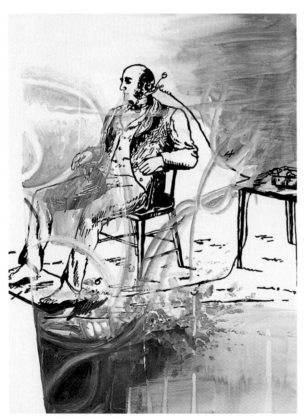

Confusion F/X, 2000
Acrylic on paper

Fairy Man, 2001
Acrylic on paper

What You Can't See (In Color), 2000
Acrylic on paper

What You Can't See (B/W), 2000
Acrylic on paper

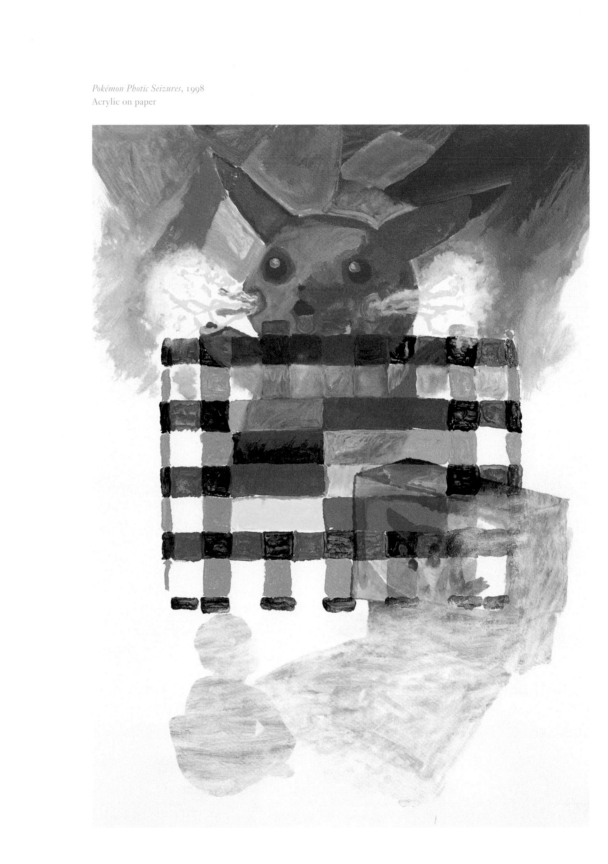

Pokémon Photic Seizures, 1998
Acrylic on paper

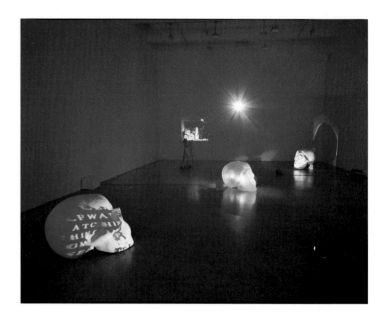

Still Lives and Skulls, 1998
Installation view

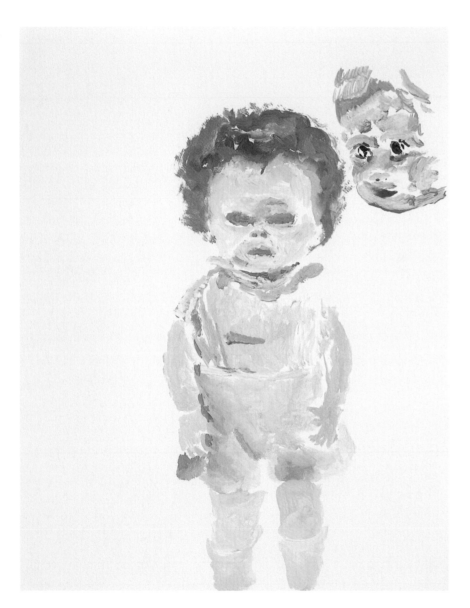

Bad Doll, 2001
Acrylic on paper

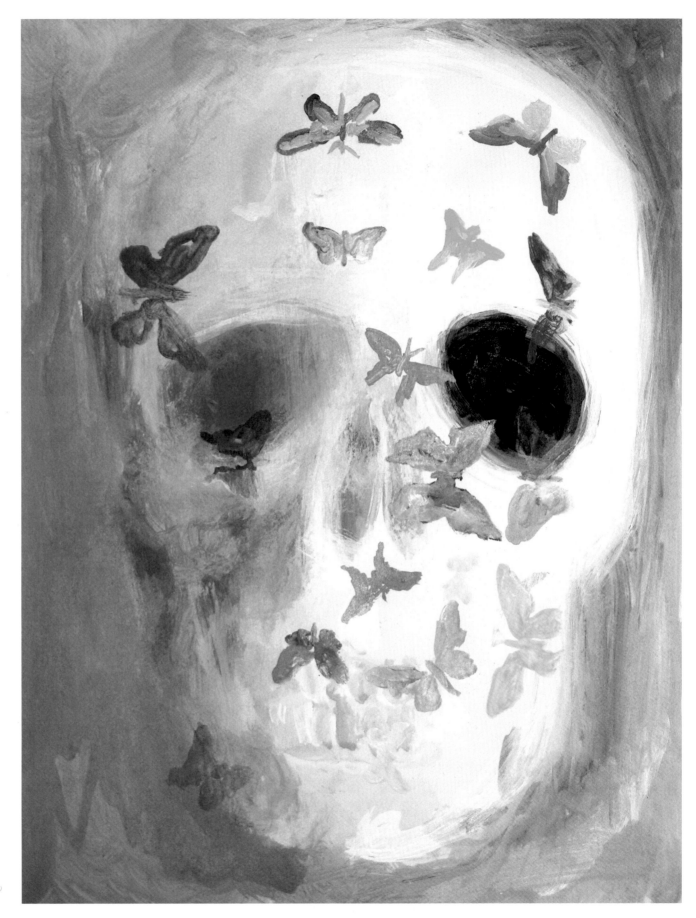

Untitled (Skull with Butterflies), 1999
Acrylic on paper

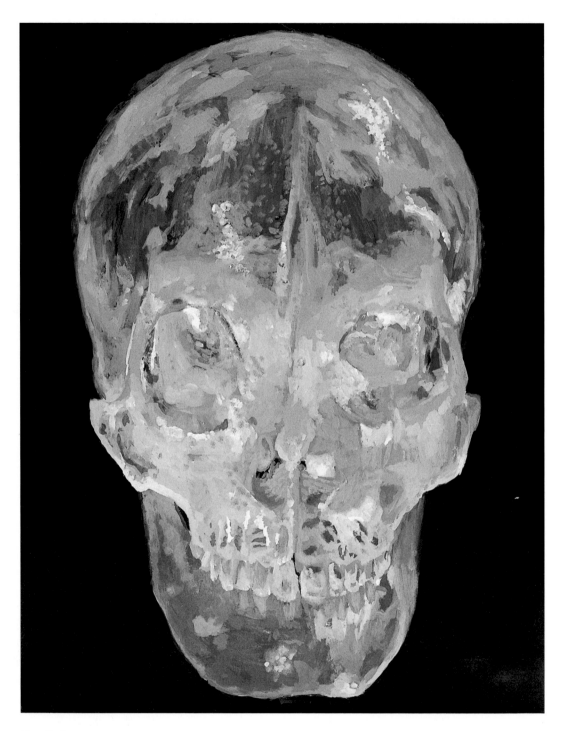

Crystalizeding, 2002
Acrylic on paper

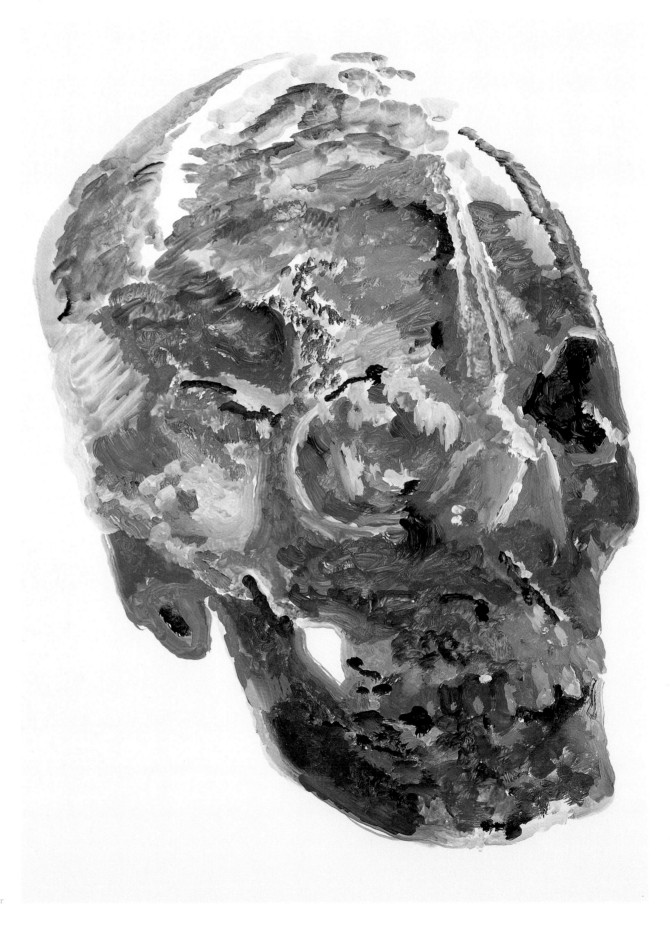

Slang, 2000
Acrylic on paper

Face, Media, and Social Flatness: On "the veiled clarity of the substances called for by the closed switch"

John C. Welchman

—To the twins of the future

The only thing that is natural to us is to represent what we see three-dimensionally; special practice and training are needed for two-dimensional representation whether in drawing or in words.
—Ludwig Wittgenstein[1]

1. Ludwig Wittgenstein, *Philosophical Investigations* (1953), Blackwell, Oxford 1963, p. 198.

Let's switch back, first, to *Tony Oursler: My Drawings 1976–1996*, the first publication dedicated to Oursler's two-dimensional work.[2] Here we encounter an unabashedly—almost flagrantly—variegated range of formats, styles, and genres. The volume includes apparently conventional media such as watercolor and acrylic, sometimes laminated in plastic, as well as drawings per se in pencil, tempera, and ink, which use such

2. *Tony Oursler: My Drawings 1976–1996*, exh. cat., Kasseler Kunstverein/Oktagon, Kassel/Cologne 1996.

common supports as paper, cardboard, foam core, and canvas, but also unusual ones such as denim and a plastic pistol. We also find video production stills (from *Life of Phyllis* and *Plastic Surgery*, both 1976, *Grand Mal*, 1981, or *Air Life Savers*, 1991, for example); several collage-like, mixed media works whose supplements to the inscription of form on a surface or volume include human hair, clay, wood, plastic gel, aluminum foil, electric lights, cast glass, photography, video camera lenses … even strychnine, among other elements. The anthology includes "installations" of painted paper and cardboard (such as that for *Twilight: Son of Oil*, 1981); "props" from videos (e.g. *Modernist Head (Alien)* from *Spin Out*, 1983); and what we might describe as special circumstance drawings deriving "from videotape from installation" (in this case, *Diagram of an Alien Visitation in Bedroom*, 1983, in collaboration with Gloria). And this is not all. There are "installation detail[s]" (*Ziggurat* from *Spheres d'Influence*, 1985, which includes acrylic on wood, VCR, TV, videotape, mirror, motor); a computer animation still titled *Death by Office*, from the installation *Pyschomimetiscape* (1987); objects that in other circumstances might be described as sculptures, such as the marble and brass *Trophy* (1987); and, finally, images from the artist's signature video projection installations, such as *Let's Switch* (1996), which rounds out the book with its

amalgam of "cloth, wood, video projector, VCR, VHS tape," and "performer: Tracy Leipold."

We learn several things from this Borgesian assemblage of works and descriptions. Most important, perhaps, is that drawing for Oursler is not a category reserved for mark making on a two-dimensional support. It is instead a particular mode of appearance of the seemingly flat. What, then, must we make of the relation of Oursler's adjudication between work in two and three (and other) dimensions to the long history of avant-garde negotiations with these and related parameters, which, in different material and conceptual inflections, makes up one of the most inclusive definitions of vanguard or experimental art in the passage from modernism to postmodernism and beyond? This is a question that turns on what we can term the territoriality of art practices, and the constitutional dispute between genres, formats, and platforms: most obviously between painting and sculpture, or flatness and illusionistic depth; but also between sculpture, film/video, and architecture; between the static conditions of the artwork and various intimations of movement; between art and non-art materials; and eventually between the designations and definitions of "art" and wider categories such as events, bodies, or life itself.

The history of video art occupies a special place in this genealogy, and Oursler's work, I will argue, plays a crucial role in the formation of new aesthetic territorialities for a new technological medium, offering a creatively salient reflection on the move from the relative flatness of screen and monitor to the dimensional palpability of projection and installational space; from the declensions of set and backdrop to the physical appearance of objects and images; and from the mass cultural circulation of TV to the projective individualism of the art world talking head. The scope and implications of Oursler's position, and its difference from and resistance to the reflexive meta-discourses of the 1980s art world, are nowhere better attested than by the investment of the first generation of media and new media critics—working in the later 1960s and later 1990s respectively, in a range of definitional questions turning on issues of space and dimensionality, that anticipate and inform Oursler's own deliberations. From the outset, the pro-

visional and uncertain dimensionality of the television image was central to the debate about its domestic appearance and social extensions. In "Television: The Timid Giant," Marshall McLuhan, for example, contends that in contrast to the density and depth of field of the film image, early television screens offered a low-intensity, "flat, two-dimensional mosaic" of forms apprehended by a viewer who "unconsciously reconfigures the dots into an abstract work of art on the pattern of a Seurat or Rouault."[3] McLuhan's aestheticist metaphorics notwithstanding, it is clear that in his signal and influential reading, the

3. Marshall McLuhan, *Understanding Media: The Extensions of Man*, Routledge, London and New York 2001, p. 341, 342.

flat, patterned, and relatively non-perspectival condition of the television image was a key paradigm for the inflection in media history represented by the new technology. McLuhan, interestingly, points out that the provision of stage sets in the TV studio offered some intimations of three-dimensional perception, based on the binary separation between foreground protagonists and various scenographic backgrounds. It was in the space of this binomial arrangement, of course, that Oursler commenced his work in experimental video in the mid-1970s. In the process, he investigated another of the definitional separations to which McLuhan alludes, that between the ultra-two-dimensionality and diagrammatic reduction of the cartoon and the mid-range detail, depth, and definition of TV.[4]

McLuhan's debate with the constitutional flatness of the TV medium is rejoined and extended three decades later by critics such as Lev Manovich who attend to the new spatial formations engendered by the computer and its monitor. In *The Language of New Media* Manovich notes that the "concept of a screen combines two distinct pictorial conventions: the

4. In an interview with the Oursler in 1992, Graeme Sullivan offers a useful account of the artist's negotiation between media image and social depth through techniques of "layering" and "muffling": "In challenging the viewer to invest in the art encounter as a critical process of negotiating meaning for themselves, Oursler used a process he described as 'layering.' The use of time-based technologies meant the TV monitor became the electronic field where this artistic encounter was played out. While the TV screen was assumed to reflect reality it could also be considered to be a construction of layers of ideas and images that were mobile in that they could be seen to emerge from, and recede into, what Oursler called a 'muffled kind of electronic grid' whereby meaning was seen to bubble to the surface." Graeme Sullivan, artist interview, November 24, 1992, cited in "Critical Interpretive Inquiry: A Qualitative Study of Five Contemporary Artists' Ways of Seeing," *Studies in Art Education: A Journal of Issues and Research*, vol. 37, no. 4, 1996, p. 219.

older Western tradition of pictorial illusionism in which a screen functions as a window into a virtual space, something for the viewer to look into but not to act upon; and the more recent convention of graphical human-computer interfaces which, by dividing the computer screen into a set of controls with clearly delineated functions, essentially treats it as a virtual instrument panel. As a result, the computer screen becomes a battlefield for a number of incompatible definitions: depth and surface, opaqueness and transparency, image as an illusionary space and image as an instrument for action. The computer screen also functions both as a window into an illusionary space and as a flat surface carrying text labels and graphical icons."[5] Few artists have worked as insistently as Oursler across the spaces that define the technological moves from TV to monitor, low lines of resolution to hi-definition, and tube to LCD. Mediated by a longstanding commitment to drawings, the shift from the sets and surfaces of his single-channel pieces to the breakthrough projection of body- and speech-bearing video onto dummies and objects turned the old-order dichotomy between two and three dimensions inside out. It bears witness to a palpable dissolution of the genres of painting, sculpture, and installation, which converge and separate according to a new performative logic distributed by an endless roster of virtual bodies conjured up by combining speech and gesture as affective virtualities. In this process, depth and reduction become allies in the project of recalibrating the surfaces and run-offs of bodies—whose "skin," real and imagined, operates as a media membrane to trap and filter the corporeal encounter.

5. Lev Manovich, *The Language of New Media*, MIT Press, Cambridge, Massachusetts 2001, p. 95–96.

In this book, and arguably in Oursler's career as a whole, the central arena for the artist's ceaseless relay between flatness and depth, surface and overlay, metaphor and hallucination, projection and introversion, even art and science, is the face itself. For the last 30 years Oursler has produced a remarkable assemblage of facial representations, a composite faciality, in effect, that includes the cutout and sculptural objects and personae (of the early sets); the projection of facial close-ups and facial part-objects (eyes, mouths, noses etc.) onto recipient effigies, dummies, and other surfaces and volumes, beginning in the later 1980s; and, more recently, augmented photographic representations of his own face and of re-embedded facial items organized into a series of pseudo-physiognomies. His reinvention of the territories and signification of the face also includes special projects which have fractured and multiplied its parts, such as the exhibition *Eyes* (1999), in which the gallery space was made over into a planetarium of suspended, desocketed eye-balls to create an eerie cosmology of disembodied gazes and shifting blinks.

Ranging, iconographically, from skulls, devil's-heads, and blob-faces, to automata, painted faces, machinic visages, and acephalic personae, the paintings, drawings, collages, and other works collected here offer a kind of summation and commentary on Oursler's signature dispersal of facial signification. Among American artists who came of age in an era once described as "postmodern," in the 1970s and 80s this interest is not unique to Oursler, of course. But his physiognomic commitments and facial obsessions are quite different in origin, conception, and materialization from the predominantly photographic images through which the modernist occlusion of physiognomic referentiality was challenged in these years. Defined by new relations to the reinvention of structures, the emptying out of the subject, and various challenges to the iconicity of the human body, the postmodern moment witnessed an astonishing sequence of reversions to somatic and facial articulation. These included Warhol's silk-screened "society icons" and later skulls; Barbara Kruger's opaquely refracted gender-heads; Lucas Samaras' series of *Photo-Transformations*; Nancy Bursen's computer generated photographic composites (e.g. *Warhead 1*, 1982; 55% Reagan, 45% Brezhnev, less than 1% Thatcher, Mitterand, Deng); and an array of new questions posed to the construction of facialized ethnicities—by Lorna Simpson (e.g. *Guarded Conditions*, 1989); Adrian Piper (e.g. *Vanilla Nightmares*, 1987); Jimmie Durham (e.g. *Self-portrait*, 1987), and others. Many

Tony Oursler
Let's Switch, 1996

Barabara Kruger
Untitled (You Are Not Yourself), 1982

of these practices of re-facialization are worked out in complex relation to the histories of facial expression and the pseudo-science of physiognomy. Burson's computer-generated portrait composites, for example, engage with the history of photographic composites, dating back to the pioneer of eugenics, Francis Galton, to 19th-century ethnological research on racial differences and criminality, as well as to subsequent experiments with the photographic composite by Laszlo Moholy-Nagy in the 1930s and William Wegman in the 1970s.[6]

6. For a preliminary formulation of these issues, see John C. Welchman, "Face(t)s: Notes on Faciality," *Artforum*, November, 1988; and John C. Welchman, "Until the Probe-head," in *Faciality*, exh. cat., Monash University Gallery, Melbourne, July/August 1994.

Oursler's concerns are not quite so genealogical, but no less historical. They have what appears to be quite a finite point of origin in the crucial convergence of facial signification with the new technologies of reproduction, narrative, and information represented by the advent and maturity first of broadcast television and then of portable video apparatuses. In the inaugural epoch of television, which extended through Oursler's childhood and adolescence, the telepresencing of bodies and faces represented a triumph for the hallucinatory intensity of the corporeal, but at the same time—by virtue of the diminutions of scale and blur of detail associated with early and second generation TV—delivered a shock to communal expectations of the palpability of the somatic forms embodied in moving images already secured in the late 1950s and 60s by the scope and resolution of film.

Beginning in his earliest projects, Oursler turned his attention to the implications and effects of the social dissemination of flatness that was the pair and consequence of the technological, imagistic, and narrative reductions of TV. As we have seen, it is across these dimensions that the artist draws the permeable boundaries for the exchange between media forms and appearance that is one of his most notable contributions. Drawing is not, therefore, one generic choice among several media opportunities, but an active term connoting a process of comparative making. Duchamp caught some of the semantic and material shifts for which I am reaching here when he noted his enigmatic commitment to "drawing on chance."[7]

Driven on by the wider implications of drawing out, Oursler's preoccupation with faces is funded by a series of general questions about the relation between bodies, representation, and social formation, as well as by more specific concerns precipitated by the apparatus and cultural engineering of TV itself. I want to begin with these speculative questions, before turning back to the focal points of Oursler's interest in the face, which connect it to the theory and practice of media. One of the largest issues before us turns on the constitution of facial realism, and the differences caught between faces apprehended through familial and social encounters and the faces met within representation. The divide between these domains has long been subject to critical and philosophic speculation; though it has also been reduced and not occasionally trivialized by unreflexive assumptions of continuity. As Susan Sontag noted in her discussion of photography, one of the key moments in this debate arrived when Ludwig Wittgenstein turned his signature skepticism to the assumptions underwriting the mimetic capacities of the face in reproduction: " … we *regard* the photograph, the picture on our wall," he wrote, "as the object itself (the man, the landscape, and so on) depicted there. This need not have been so. We could easily imagine people who did not have this relation to such pictures. Who, for example, would be repelled by photographs, because a face without colour and perhaps even a face in reduced proportions struck them as inhuman."[8] What Wittgenstein attacks here is the apparently remorseless capacity of mimetic theories of representation to elide the manifest differences between person (or place) and image. The philosopher's apparently calm and understated inference, arising from the hypothetical readings of a class of counter-mimetic viewers, turns the humanistic assumptions embedded in the mimetic reading of images literally upside down; so that an image of this or that face

7. In a letter to Francis Picabia written from the Café de Paris in Monte Carlo in 1924, Duchamp emphasizes the mechanical, repetitious character of the work that informed *Obligations pour la Roulette de Monte-Carlo* or *Monte Carlo Bond* (1924), its "delicious monotony without the least emotion." His effort is a kind of geometric abstraction, worked out between "the red and the black figure," in which, as he so curiously puts it, he is "sketching [or, in other translations, 'drawing'] on chance"; *The Writings of Marcel Duchamp*, eds. Michel Sanouillet and Elmer Peterson, Da Capo, New York 1973, p. 187.

8. Ludwig Wittgenstein, cited in Susan Sontag, *On Photography*, Penguin, Harmondsworth 1979, p. 198.

or person is less a "likeness" or version of a embodied original, but instead a potentially monstrous defection from it characterized above all by its "inhumanity." Oursler has been continuously interested in a creative re-making and re-reading of faces staged at the thresholds of received systems of codification and interpretation; and has frequently used the upside model of the camera obscura as a figure for the media inversions investigated in his work. It is not surprising then, as we will see, that he takes up with the critical space between the "this need not have been so" of representation and its deviant or counter-human implications.

The broadly-based iconoclastic skepticism of Wittgenstein raises a related, but more discursively targeted, question about the relation of faces to the class or type of representation formalized, first by artists, then by art historians, over the last half millennium as "portraiture." But while never forgetting the generic implications of historical portrait models, Oursler is clearly more interested in what lies on the other side of their formalized encodings of specific persons and social types. Many of his faces, including several in this book, are sited on the very threshold of identification *as faces*. They emerge from the representation and permutation of certain basic semaphoric units of facial order, schematic minima that engender the projected—or conjectured—presence of facial volume accompanied by intimations of the key facial part-objects (eye, nose, mouth). This process is aligned on an axis of signification that seems to have two extremities, predicated on two versions of our negotiation with the initial recognition and apprehension of faces.

The first of these is configured around flat, diagrammatic reductions of the face, long part of the codified accountancy of physiognomic analysis, but popularized in recent times by the omnipresent "smiley face" and its legacy of lightly inflected emoticons,[9] to which Oursler refers in his writings and which he appropriates in several works—directly, in e.g. *Have a Nice Day* (2006, p. 98), and indirectly in a spectrum of goofy, anime, and doughnut faces (in *Visitation*, 2003, p. 55; and

9. Wittgenstein develops an important discussion of the emotive signification of a smiley-type "face primitively drawn" in the *Brown Book*; see *Preliminary Studies for the "Philosophical Investigations". Generally Known as the Blue and Brown Books*, Blackwell, Oxford 1958, p. 162; see also, p. 179f.

Untitled, 2003, p. 55). Probably first developed (though not copyrighted) by David Stern of the eponymous advertising agency in Seattle around 1967, the smiley face simultaneously completes and aborts the abstracting journey of the avant-gardist facial sign commenced by the geometric reductions of the Cubists, emblematized in the paintings of Alexei Jawlensky, and given its most radical inflection in the emotive metaphysics that underwrote Kasimir Malevich's Suprematist works from the later 1910s which he correlated, in theory and physical placement, with that apogee of facial presence and transcendence represented by the icon tradition of the Orthodox church. In the later 1960s, the schematic face is made over as the common coinage of one-dimensional emotivity. Eagerly adopted as a commodity supplement by the merchandizing instincts of post-1960s commercial culture, it was at first rhymed with the popular positivism of the peace and love generation, and then taken up, with avid over-determination, in the techno-corporate emergence of the computer era, where its use has exploded in ubiquitous typographic and text-based permutations, various animated GIF formats, and a myriad other image representations. The face in this condition has, quite literally, been grafted onto social superficiality. All its speculative depth has been foreclosed by a process of almost perverse syntagmatic reallocation as the face becomes a misbegotten *short-hand* for the universalizing complacency of mindless affirmation.

The second extreme emerges rather more distractedly in the spaces between facial perception and recognition, where it arises from a compulsion to generate facial signification triggered by certain complex, form-shifting platforms (such as clouds, textured walls, photographic tonalities, etc.)

Tony Oursler
Gold Walk, 2005

Alexei Jawlenski
Abstract Head,
1923

and is activated by our facially denominated projective capacities—part of a psychological disposition termed "pareidolia" in which people see organized, often anthropomorphic, patterns in apparently formless material or "noise."[10] This end of the

10. See Carl Sagan, *The Demon-Haunted World: Science as a Candle in the Dark*, Random House, New York 1995, esp. p. 45: "As soon as the infant can see, it recognizes faces, and we now know that this skill is hardwired in our brains. Those infants who a million years ago were unable to recognize a face smiled back less, were less likely to win the hearts of their parents, and less likely to prosper. These days, nearly every infant is quick to identify a human face, and to respond with a goony grin." See also, Stewart Elliott Guthrie, *Faces in the Clouds: A New Theory of Religion*, Oxford University Press, Oxford 1993, which interrogates the concept of anthropomorphism in theories and practices of animism, perception, art, philosophy, science, and religion, concluding that it is a determining cognitive strategy for making sense of natural and other contexts and environments.

spectrum of facial projection has been associated with both the conjuring capacities of the imagination (as in the facial configurations alluded to by Aristotle, Pliny, Alberti, and Leonardo da Vinci) and with the apparatuses of myth, legend, and religious and mystical devotion (as in the *volto santo*, the Shroud of Turin, the man in the moon, and numerous face-landscape correlations—including, for example, a recent bid to facialize the surface of the planet Mars, derived from skewed photogrammetrical readings of NASA photographs by the Near Pathfinder Anomaly Analysis group, NPAAG).[11] The torrential reinscription of facial presence in and across the natural and cosmological worlds has attracted both enthusiasts and radical skeptics from the ranks of poets and philosophers. Novalis, for example, once noted that, "Anything that is strange, accidental, individual, can become our portal to the universe. A face, a star, a stretch of countryside, an old tree etc., may make an epoch in our inner lives. This is the great reality of fetish worship."[12] In a statement that did much to commend him to the Surrealists and their commentators, Novalis builds here an empire for the subjective self predicated on a constellation of emotively-charged glimpses—of "a face, a star, a stretch of countryside … " In doing so he conjugated the fetishization of the chance encounter with the virtual history (that "inner epoch") of subjective experience. His chosen symbols of this para-time played out in the inner life are coordinated in a Romantic variant of the face-star-landscape

11. See Michael Kwakkelstein, *Leonardo da Vinci as a Physiognomist: Theory and Drawing Practice*, Primavera Pers, Leiden 1994; and http://www.mufor.org/ares/.

NASA Photo of Mars/Face

12. Novalis, Neue Fragmente no. 259, cited in Werner Spies, *Max Ernst: Collages: The Invention of the Surrealist Universe*, Abrams, New York 1991, p. 11.

system that underwrites the articulation of *faciality* in the writings of Gilles Deleuze and Félix Guattari.[13] Obsessed as he was by the metaphysical and everyday conditions of correspondence and the social stakes of similitude—both of which converge in his wider project of "materialist physiognomy"—Walter Benjamin discusses some of the limit-terms (and inevitabilities) in the analogization of faces: "We start with 'similarity.' We then try to obtain clarity about the fact that the resemblances we can perceive, for example, in people's faces, in buildings and plant forms, in certain cloud formations and skin diseases, are nothing more than tiny prospects from a cosmos of similarity."[14]

In "Pop Dead Pictures" (2002), Oursler offers his own account of the production of "regenerative portraiture" accompanied by a latter-day parable derived from a contemporary "pilgrimage." Writing of the aftermath of the 9/11 catastrophe, which unfolded close to his own residence and studio in downtown Manhattan, he notes that "almost everyone who made the gruesome pilgrimage wanted to do one thing: take pictures with their cameras. I started shooting the people shooting Ground Zero, studying the way they related to their cameras … People are selling horrific snapshots of the event, and one series of images are marked, 'devil's head.' The peddler explained, 'if you look closely you can see the face of the devil in the red-orange fire ball.'"[15] As Carl Sagan and others have suggested, the extrapolation of facial references from nonsentient configurations might be occasioned by the remnants of a reflex defense mechanism designed to anticipate any form of danger or surveillance. Here, however, the demonic hallucination is predicated on a willful polarization between creeds and ethnicities, emerging as the perverse afterimage of a moral and religious binarism that is already in place in the prejudicial imaginary of the

13. See Gilles Deleuze and Félix Guattari, *A Thousand Plateaus: Capitalism and Schizophrenia*, vol. II, trans. Brian Massumi, University of Minnesota Press, Minneapolis 1987, chapter 7, "Year Zero: Faciality," p. 167f.

14. Walter Benjamin, "On Astrology," in *Walter Benjamin: Selected Writings, Volume 2, 1913–1926*, eds. Marcus Bullock, Michael W. Jennings, Howard Eiland, Gary Smith, Harvard University Press, Cambridge, Massachusetts 1999, p. 684.

15. Tony Oursler, "Pop Dead Pictures," in *Tony Oursler*, exh. cat., Museo d'Arte Contemporaneo Roma (MACRO), Rome 2003, p. 163.

viewer/interpreter. The leering, flickering, red-hot, flame-bound devil's head makes a deviant pair with its would-be benign obverse, the coolly static symmetry and eviscerated emotions of the happy-yellow smiley-head.

In his own representations, Oursler develops an extended meditation on the postmortem, counter-physiognomy of death in a series of skulls and demons done in acrylic on paper and other media. In *Untitled* (1999), p. 25, a skull is flecked with butterflies as if the worms of decay which devoured the flesh have blossomed into pluralized rounds of colorfully transient life. *Crystalizeding* (2002) offers the skull without entomological supplementation as a garishly translucent phantom, a cranial mass haunted by what had formerly possessed it, appearing like an X-ray of what is already interiorized and skeletal. In earlier works developed around the death's head, Oursler produced literalizations of diabolic personae, such as the *White Devil*, *Devil's Head with Green Light*, and *Devil and Angel* constituents of his *Optics* exhibition at MASSMOCA (1999); or staked out alliances with his central thematic concerns, as in *Early Cinematic Device in Red* (1997), which couples the mortuary form of the skull with the cinematic apparatus and its effects.

Elsewhere, the image of the head is caught somewhere in the middle of its dreadful journey toward death and decay (as in the craggy, misfit face of *Kill or Be*, 1997). In the exhibition *Still Lives and Skulls* at Metro Pictures in New York in 1998, Oursler created perhaps his most notable and ghoulish array of skull-like forms: in *Poetry* (1998) the skull is a projection screen for a heart-shaped tombstone; in *Feedback* (1998) it inflects and absorbs a slab-like grid of text that overflows onto the wall behind it. Other skulls spill dime-store jewelry from their eye and nasal sockets, or, as in *Fear* (1998), are beset by garlands of chains and garish paint-pours. The skull in *Flame* (1998) becomes a candle-bearing altar, while in *Ghost Bell* (1998) a hulking, whitish skull is impacted by the bullet-like projection of lips and teeth on its boney forehead. *Crystal Skull*, also shown at the Manchester Art Gallery in 2003, takes the form of a huge fiberglass skull flashing out both colors and hypnotic discourse

on blind spots and floaters. And *Hole*, shown at THE LAB in San Francisco in February 2001, features a large skull with a video projection of a moving mouth.

That Oursler relates his own development of the skull and death's head motifs to historical conceptualizations of death is attested by clear references to the tradition of the memento mori, and by his elision of these allusions in *Composite Still Life* (1999), with its playful re-examination of the compound skulls of Salvador Dalí such as *The Face Of War* (1940), or Philippe Halsman's photograph, *In voluptas mors* (1951), which features the artist and a life-skull assembled from seven naked female bodies. Oursler's skulls take on more than

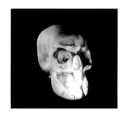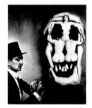

Tony Oursler
Composite Still Life, 1999

Philippe Halsman
In voluptas mors, 1951

the mannered endgame of the vanitas tradition, however. Considered as a congregation of spent or rotten heads, this defleshed body of work is an allegory of the morbid conditions of mediated experience itself and of the exhaustion and capitulation of the artist's situational psychodramas. They shuttle us across Oursler's river Styx of negative becoming, carrying us over to a nether world of disembodied demonological diminishment where we are virtually re-constituted by our fears, prejudices, and nightmares. Oursler thus stakes out a crucial third position between two key mortuary visions in recent art. The first of these is set out in Warhol's series of skulls (1976–1977) and self-portraits, which figure an intimation of mortality haunted on one side by the fading-unto-death of celebrity and on the other by what Hal Foster described as the social unconscious of *Death in America*.[16] The second is ventured by Damien Hirst's *For the Love of God*, a re-dentured 18th-century human skull encrusted with some 8,600 diamonds and valued at $100 million, which raises death as expenditure to a flash point of aesthetically-inflected commercial obscenity.[17]

16. On Wahol's skulls see Trevor Fairbrother, "Skulls," in *The Work of Andy Warhol*, ed. Gary Garrels, Bay Press, Seattle 1989; and Hal Foster, "Death in America," *October*, vol. 75, Winter, 1996, p. 36–59.

For Oursler, however, death and its heads are not the great levelers of the rich and famous or nightmares of popular misfortune, nor again, as with Hirst, gathered up in an über-vanitas that summarizes and fulfills the art world's teleological drive for value.

17. See, http://news.bbc.co.uk/2/hi/6712015.stm. On Oursler's dialogue with the skull, see Ian MacMillan, "Expressway to Your Skull," *Modern Painters*, Spring 1998, p. 77–79.

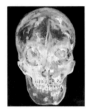
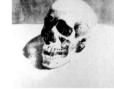

Tony Oursler
Crystalizeding, 2002

Andy Warhol
Skull, 1976

Instead, Oursler has excavated in his skulls for another sequence of relations in which they become chambers for the generation of images as well as motifs in the iconography of passing. Building on the cavernous, engorged eyes assembled for a show in 1996 that acted as spherical housings for image production, some of the skulls in the 1998 exhibition also do double duty as representational machines—an association that is followed-up in several of the drawings—as their hollowed-out heads are converted into camera obscura-like spaces brimming with incipient imagery. In conversation with Elizabeth Janus, Oursler underlines this reference: "It seemed to me at this point that the skull was only one step away from the camera obscura: a dark chamber with light streaming through an opening—the empty eye socket—into the lost sea of consciousness."[18] Something similar is attempted by Marcos Novak in his *AlloBrain@ AlloSphere*, a project in which scans of Novak's brain become reflexive agents for the generation of spatial environments. By

18. Tony Oursler in Elizabeth Janus, "Talking Back: A Conversation with Tony Oursler"; http://www. tonyoursler.com/tonyourslerv2/words/interviews/ elizabethjanus.htm.

transforming void into mass he is able to "inhabit" his own brain or extrapolate particular sections of it as architectural models. Oursler works with a variant of this delicious conceit, converting the dead head into a cinema of fantasies by reinvesting it with imagistic thoughts taken from a prior life. By opening up his skulls from the inside and contouring them with projection he converts them into mediumistic resurrections, exhuming images culled from long nights of the living dead.[19]

Posed in the semantic space between the death's head and the knowable social subject are a range of faces that attach to inanimate dolls, automata, and hybrid personae, such as *Bad Doll* (2001, p. 24), which images a scowling, curly-haired, dark-skinned, racially ambiguous female doll posed frontally, while a smiling, cherubic-cheeked, disembodied male head appears over its shoulder; works that feature acephalic figures such as the headless female in *Neg Leg* (2003, p. 57); and others that take on the scrambling, rescaling, and reorientation of body—but especially facial—parts, as again in *Neg Leg* with its monocular eye, embedded in an ear-like protrusion that is itself cut-off from any sustaining corporeality, or *Untitled* (2003) which images two homunculus-like busts outcropping from an eye and the nose of a schematic circular face. In *Blox Flox* (2003) we encounter a trio of enlarged eyes hovering in Cubist-like facets over a bearded male death mask; and in *Twiced* (2004) two eyes, one encased in a boulder-like mass, the other set in a burr-edged balloon-shaped field, return to Oursler's concern with the physiognomic signification of the eye, the guarantees it offers of one of the semantic minima required for the identification of a "face," and its capacities to follow, surveil, or watch the viewer back. The plurality of these faces stands in for the heterogeneity of the faces encountered in everyday and mediated life, from random faces on the streets to TV talking heads; from facial surrogates, such as those atop dolls or mannequins, to the wider morphology of face-like shapes and facial parts in blobs, balloons, and balls.

19. On Marcos Novak's *AlloBrain@AlloSphere*, see http://www.mat.ucsb.edu/allosphere/.

For Oursler, however, there is one location for the redistribution of facial signification between the extremes of death and social vivacity that takes center stage in his work as a whole, and in particular in his drawings. This is a scene in which faces in their various conditions and appearances, some as described above, are posed with or superimposed upon a "ground" made up of machinery or technological instruments or apparatuses. *Horror Harmonies* (2000, p. 11), for example, stands at the intersection between Oursler's interest in the apparatuses of recording, transmission, and construction, and the signifying proclivities of the human

head. Floating in a field of antennae, the face represented here is a ghoulish hirsute apparition with asymmetrical bug eyes and a lolling tongue, whose iconographical allegiance layers a horror flick hippie over the manic contrivances of medieval demonology (see also *Gothic (sic)*, p. 17). In some works the enmeshment between face and machine is confrontational, as in the "tortured" yet somehow comedic figure-of-eight face in *No Yes Yes* (2003), which is literally pierced by the apparatus around it. *Chine* (2003, p. 58), also images a female head embedded in mechanical elements, this time with her eyes patched by ovals bearing diagrammatic enlargements of anime eyeballs; while in *Unkie* (2002–2003, p. 61), the profile of a friend on a methadone high—with stubbly chin, open mouth, and closed eyes—stares across at a corner bracing made of girders and beams separated by a reddish, dripping, paint splash, with a teddy bear below.

The importance of this defining relationship between head and machine is both recognized and underlined by artist. "The Antennas," he wrote, "needed faces but they had to be wandering in their own atmosphere, lost in the ether, unstable. Moving lights were used while shooting to emphasize the shapes and dimensions of the faces, like the way a person looks in a car driving at night. The faces are constantly being formed visually: chiaroscuro in waves of light. Then I needed the faces to move in a mechanical slide or loop, like a TV rolling. This was done with computer animation; they bend and distort as they travel over the surface of the sculpture. There is a lot of power, tension in the juxtaposition of the three kinds of movement: human, light, and mechanical."[20] On this account, the soft circularity and caricatural plasticity of faces answered the need of the aerials and antennae omnipresent in Oursler's work for a pseudo-corporeality defined by morphological indeterminacy, ceaseless movement, and luminous dissolution.

20. Oursler, "Pop Dead Pictures," p. 159.

Oursler elides the face in its condition as an entropic, floating sign with technological and ethereal iconography in a manner that looks back to, but finally turns away from, the physiognomic declensions of the historical avant-garde. I want briefly to consider three moments in this engagement. In the *noirs* of Odilon

Redon, first of all, the face is promiscuously allied to a startling range of biomorphic shapes including planets, the nimbus, auras, the portrait oval and cellular forms—as well as to monsters and hybrids, such as Cyclops and demons, and technological objects, including the hot-air balloon (*Eye Balloon*, 1878). Oursler, in fact, shares many of Redon's interests and obsessions: his magnification, engorgement, and distortion of the facial envelope and its features; a fascination with the enucleated

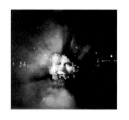 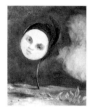

Tony Oursler
The Influence Machine, 2000–2002

Odilon Redon
Strange Flower, 1880

eye and the correspondence between face, plants, and landscapes (Redon's *Strange Flower (Little Sister of the Poor)*, 1880, *Little Flowers (Human Heads)*, 1880, or *Marsh Flower*, 1882; Oursler's tree-face from *The Influence Machine*, 2000–2002, p. 144). Both took on the facialized power of nightmares and visions (Redon in *Nightmare*, 1881; Oursler in *Dream Test*, 2001); and both investigated monstrous, bestial, and demonic physiognomies (see Redon's *Devil*, *Satyr*, and *Black Angel*, all 1877; and Oursler's *Confusion F/X*, 2000). But there are further striking alignments between the two artists. Both establish satirical but compulsive dialogues with contemporary science, Redon with evolution and electricity, Oursler with the history and reception of imaging technologies and their apparatuses. Both are equally compelled by the genres of horror, science fiction, and ghost stories— Redon looking to Edgar Allen Poe (to whom he dedicated his second

 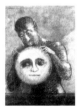

Tony Oursler
Confusion F/X, 2000

Odilon Redon
Devil, 1877

lithographic album in 1881) and to the "tenderly melancholic" monstrosities of his own short fiction (such as "The Story of Mad Marthe," c. 1878),[21] Oursler responding to Hitchcock, B-movies, and UFOlogy. What changes in the century between Redon and Oursler, between the threshold of the era of mass technological consumerism and its triumphalist, globalizing heyday, arises of

21. On "Le récit de Marthe la folle" [translated here as "The Account of Mad Merthe"] see Douglas W. Druick and Peter Kort Zegers, "Taking Wing, 1870–1878," in *Odilon Redon: Prince of Dreams, 1840–1916*, exh. cat., The Art Institute of Chicago/Abrams, Chicago/New York 1994, p. 103–104.

Positivist fantasy to the haunting of everyday life by media spectacle received as repetition and multiplicity.

A second moment of convergence and separation is offered by Francis Picabia, who overlaid machines, faces, and various attributes of identity in quizzical, title-charged, text-bearing couplets in his famous series of "machine-portraits" made between 1915 and 1918, five of which appear in the journal *291* no. 5/6, 1915 (*Ici c'est Stieglitz foi et amour*, *Le Saint des Saints*, *De Zayas! De Zayas!*, *Voila Haviland*, and *Portrait d'une jeune fille américaine dans l'état de nudité* [*Portrait of a Young American Girl in the State of Nudity*]). Picabia correlated his mechanophilia with his experience of American technological modernity, writing in the same year that, "the genius of the modern world is machinery, and … through machinery art ought to find a most vivid expression." "The machine," he continued, "has become more than a mere adjunct of human life. It is really part of human life—perhaps its very soul."[22] Picabia's deployment of the machinic reference was, however, seldom straightforward or explicit. He used it instead as a pervasive metaphorical delivery system for concerns that were, by turns, satirical, erotic, misogynistic, automotive, primitivizing, and self-consciously absurdist. In *Poems and Drawings of the Daughter Born Without a Mother*, for example, the machine makes appearances as a pretext for humor ("witticism machines"), absurdity or dysfunction ("pointless machine"), amorousness ("current views in love machine"), which are set off by references to "gear chang[ing]," "electric light globes," and "wireless telegraphy."[23] In the preface to *Thoughts without Language* he simultaneously supercharges and obfuscates the tropic potential of modern machines by crossing the on/off binarism of the switches which activate them with the interior vision of the X-ray: "This book is the radiograph of the radiation best showing the veiled clarity of the substances called for by the closed switch."[24]

22. Francis Picabia, cited in Rudolf E. Kuenzli (ed.), *New York Dada*, Willis, Locker and Owens, New York 1986, p. 131.

Oursler too creates dissident compounds for machinery and technological devices with the portraiture genre and questions of identity. While his own self-portraits and the paint-smeared faces of studio assistants and colleagues are associated more with the kind of radical pictorialist cosmetics adopted by the Russian Futurists[25] than the machine-oriented pseudo-personae of Picabia, his personal acquaintances make occasional appearances, as with the drug-afflicted profile in *Unkie* (2002–2003, p. 61). But Oursler's variant of the machine-portrait is played out in reference less to his own avant-garde circle than in dialogue with historical protagonists who have played decisive or eccentric roles (often simultaneously) in the development of image and media devices, including many that were unrealized or never entered into commercial production.

Kircher's Actor (2000, p. 16) pays homage to Athanasius Kircher, a 17th-century German Jesuit scholar who authored some 40 works in Latin on a heterogeneous range of subjects including oriental studies, geology, medicine, Egyptology, and music theory. Kirchner was well known for his research-based trans-disciplinary speculations. In *Magnes*, ostensibly a discussion of magnetism, for example, he also discoursed on other forms of attraction such as gravity and love. Oursler is interested in a special instance of these

23. Francis Picabia, *I Am a Beautiful Monster: Poetry, Prose, and Provocation*, trans. Marc Lowenthal, MIT Press, Cambridge, Massachusetts 2007, p. 60.

24. Francis Picabia, "Preface [signed "Udine"] to *Thoughts without Language*," in ibid., p. 153. Linda Dalrymple Henderson notes that X-rays were seen as "a scientific confirmation of clairvoyant vision," "Francis Picabia, Radiometers, and X-Rays in 1913," *The Art Bulletin*, vol. 71, no. 1, March 1989, p. 118.

25. On the painted faces of the Russian Futurists, see Marjorie Perloff, *The Futurist Moment: Avant-Garde, Avant Guerre, and the Language of Rupture*, University of Chicago Press, Chicago 2003, p. 93–95; Ilya Zdanevich and Mikhail Larionov, "Why we paint ourselves: A Futurist Manifesto, 1913," in John E. Bowlt (ed. and trans.), *Russian art of the avant-garde: Theory and criticism 1902–1934*, Viking, New York 1976, p. 79–83; and John E. Bowlt, "Faces Painted with Fanciful Patterns," in *Literature and the Arts of the 20th Century: USSR (Avant Garde: Interdisciplinary and International Review, 5/6, 1991)*, ed. Jan van der Eng and Willem G. Weststeijn Rodopi, Amsterdam and Atlanta, Georgia 1991.

Tony Oursler
Colost, 2004

Larionov/Goncharova
Drama In Cabaret 13, 1914

extrapolative scenes which aligns Kirchner's representation of the camera obscura (one of the first) with the moral binarism of good and evil—the latter represented by a half-effaced horned devil to the left, whose image is inverted in one of the chambers; the former by a scaled rank of real and up-side-down crosses. *Tracer* (2001–2002, p. 20) presents us with a black and white outline image of Franz Anton Mesmer (1734–1815), whose discovery of what he termed *magnétisme animal* (animal magnetism or "mesmerism") led to the development by James Braid (1795–1860) of hypnosis in 1842. Mesmer is shown seated in a chair, tethered by his ears and feet to a machine, perhaps a version of the "baquet" described in historical accounts of mesmeric sessions, on a table behind him. For Oursler this is a scene of phantom concentration presided over by an improbable apparatus and best by obscure numerology, painterly force fields, and snake-like, animal-headed, auratic emanations. Long compelled by the fault lines between subjective states and the machines that induce and record them, Oursler's Mesmer is an emblem of those speculative conjunctions of occult practice and pseudo-science which might bear witness through the willful persistence of their instruments, measurements, or assumptions to salient innovations in technological selfhood. It is not surprising, therefore, that in the grisaille swirls and unspecific protuberances of *Mediumud* (2001, p. 9), with its tripod-mounted camera, two crew, and video-subject, we encounter a similar register of contextual ambiguity and haunted mediation.

The installation with projection, *Box* (1997), turns on another relay between technology and its historical progenitors. The left wall of this open structure features a photomontage of John Logie Baird (1888–1946), the Scottish engineer who is credited with the invention of the electro-mechanical television, which he called a "televisor." Surrounded by the numerous lightbulbs needed for his experiments, Baird appears in the company of a ventriloquist's dummy nicknamed "Stooky Bill," who was the subject of the first television picture produced with halftones in a 30-line vertically scanned image at five pictures a second in October 1925. Oursler's focus on the dummy reappears in several works including *Psycho Satellite* (2002), featuring Harry Kellar's (1849–1922) automaton

"Psycho," a version of John Nevil Maskelyne's (1839–1917) original card-playing robot, and another drawing that pairs Baird and Stooky Bill, *Baird vs Future* (2004, p. 56). It points to both the happenstance correlation of invention with amateur diversions,[26] and to another of the abiding interests of the historical avant-garde in the era of Picabia, which produced what amounted to a fixation on mannequins, dolls, and dummies, from the paintings of Giorgio de Chirico, to Surrealist and modernist German photography, and the sculptural objects of Hans Bellmer.[27] Like Picabia, too, Oursler injects the installation with a dose of sexual prurience by fixing stretched female garments to the wall opposite the Logie Baird photograph; while the space between them is hung with a shower curtain in a gesture that recalls Hitchcock's *Psycho* (1960).

Fairy Man (2001, p. 21) and *Tune Mort* (2003, p. 49) furnish two final examples of Oursler's machine-assisted quasi-portraits. Traced from a projected photograph, *Tune Mort* represents the Latvian-born psychologist Konstantin Raudive (1909–1974) at work on one of his recording devices; while *Fairy Man* shows a close-up from the same source of Raudive's disembodied hands, set in a box at the top right. A data-specific globe and various red-hued birds and fairy figures appear below. Known for the some 72,000 "spirit voices" he tape-recorded during his Electronic Voice Phenomenon (EVP) research, known in English as "Breakthrough," Raudive's experiments provide Oursler with a sonic inflection of

26. Another example of the plurality of the inventive mind is furnished by Maskelyne himself, who, in addition to his work as an English stage magician, invented a lock for London toilets which required a penny to operate, hence the euphemism "spend a penny"; http://en.wikipedia.org/wiki/John_Nevil_Maskelyne.

27. For discussion of the interest in mannequins, dolls, and automata and its relation to Freud's concept of the uncanny, see Mike Kelley, "Playing with Dead Things," and John C. Welchman, "The Uncanny and Visual Culture," in *The Uncanny*, exh. cat., Tate Liverpool, Liverpool 2004; exhibition curated by Mike Kelley. Tony Conrad discusses Oursler's relation to the tradition of the ventriloquist's dummy inaugurated in the mid-18th century in his essay, "Who Will Give Answer to the Call of my Voice: Sound in the Work of Tony Oursler," in *Tony Oursler*, ed. Elizabeth Janus and Gloria Moure, Ediciones Poligrafa, Barcelona 2001, p. 150–166.

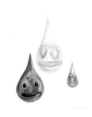

Tony Oursler
Untitled, 2003

Mike Kelley
Cry Baby (from *Monkey Island*), 1993

the machine-assisted channeling and precipitation of invisible forms manifested in waves or frequencies. Like Tristan Tzara, who once referred to "the banditry of the gramophone, the little anti-human mirage that I like in myself,"[28] Oursler seizes on Raudive's obsessive archivalism as another way station in his ironic cosmos of appropriating, mediumistic machines, setting it alongside a speculative fairyscape presided over by his imagistic equivalent of Tzara's "world tottering in its flight, linked to the resounding tinkle of the infernal gamut."[29]

28. Trsitan Tzara, "MONSIEUR AA THE ANTIPHILOSO-PHER SENDS US THIS MANIFESTO," in *Seven Dada Manifestos and Lampisteries*, Calder, London 1977.

The governing apparatus in Oursler's technological firmament is the antenna or aerial, the privileged object that receives and decodes transmissions or signals, such as those produced or intercepted by Baird and Raudive,

29. Tristan Tzara, "Dada Manifesto 1918," in *ibid*.

and to which, as I noted above, Oursler attributes a determining "need" for "faces." Presiding over some dozen works collected here, it appears as a solitary icon in *Untitled* (2001), and *Anti* (2002, p. 8); as transmission lines and their supporting structures in *Power Pole* (2002, p. 14); as a background grid or motif in *Visitation* (2003, p. 55), *Transformeds* (2003), and *Horror Harmonies* (2000, p. 11), which reproduces the demonically possessed girl from *The Exorcist* (1973, dir. William Friedkin). Almost inevitably, Oursler is also drawn to the visual appearances of the signals themselves, whether as auras and emanations, in *Confusion F/X* and *Tracer*; ciphers for the shapes of the invisible in *What You Can't See*

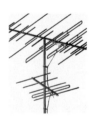

Tony Oursler
Untitled, 2001

Suzanne Duchamp
Radiation de deux seuls éloignés, 1916–1920

(B/W) (2000, p. 22), and *What You Can't See (In Color)* (2000, p. 22); or patterns, test-screens, and other formal notations as in *Pokémon Photic Seizures* (1998, p. 23), *Pickup* (2002, p. 19), *Nordic Test* (2002, p. 51), and *Untitled* (2003), in which the artist poses a transvestite Cyclops and female adolescent head with a scrambled version of a color chart based on thermal imaging. *Freqlot 2* (2002, p. 53) and *Frequency Spectrum* (2002, p. 52), another three-

dimensional structure, are both defined by variants of the frequency spectrum charts that Oursler researched in Scandinavia for the exhibition *Station* (Magasin 3, Stockholm, 2002) while working with a TV station and its already outmoded 1980s-era equipment, which he purchased in order to experiment with obsolescence and feedback.

While Picabia himself doesn't appear to have used the iconography of the antenna in his machine-based works, Suzanne Duchamp expanded on her brother's interest in the relation between wireless communication and erotic desire in *Radiation de deux seuls éloignés (Radiation of Two Lone Ones at a Distance)* (1916–1920). According to Linda Dalrymple Henderson, "The upper form resembles a cage-type emitting antenna and the lower gridded one implies a surface on which the 'radiations' are to be recorded." The "theme," she suggests, "seems to echo that of the *Large Glass*: here an antenna-like 'Bride' (Suzanne herself?) projects her message."[30] Revealing a probable source for *Radiation*, Henderson reproduces alongside it a contemporary example of the cage-type antenna from Henri Poincaré and Frederick Vreeland's *Maxwell's Theory and Wireless Telegraphy*.[31] The frank sexualization of machines by the Dada artists, whether analogized by Picabia's spark plug, the chocolate grinder of Marcel Duchamp, or the antenna-like bride of Suzanne, has given way in Oursler's epoch to a media-driven regimen of sexual dysfunction, infantalization, and bathos. Oursler's commentary on this diminuendo of the erotic is, typically, both comic (in the manner of what Duchamp termed "playful physics")[32] and satirical. In *Handsome* (2003, p. 53), for example, a rank of five leering, high-color, mask-like faces, some with moustaches, others with demonic horns, float in front of a monochromatic environment that might be an early TV studio with its boxy cameras, small, blurry screens, and formally

30. Linda Dalrymple Henderson, "Wireless Telegraphy, Telepathy, and Radio Control in the Large Glass," in *Duchamp in Context: Science and Technology in the Large Glass and Related Works*, Princeton University Press, New Jersey 1998, p. 112.

31. Henri Poincaré and Frederick Vreeland, *Maxwell's Theory and Wireless Telegraphy*, New York, 1904, p. 142.

32. *Salt Seller: The Essential Writings of Marcel Duchamp (Marchand du Sel)*, eds. Michel Sanouillet and Elmer Peterson, Thames and Hudson, London 1975, p. 49.

attired audience. Filtered through the mid-20th-century diminishment of the erotic into dress-codes and appearance driven on by the American media machine, the faces offer a choric commentary on the emergence of a knowingly impossible lust—by turns disembodied and devilish—that emerges from the dusty protocols of the "handsome" Hollywood movie star or the trustworthy TV talking head.

My third point of reference for Oursler's compound of face and machine is provided by Fernand Léger who painted several works during the mid and later 1920s in which the face stares passively, often in old-order, classical profile, into the competition of mechanical forms, elements, and man-made shapes that crowd out the modern environment. *Composition avec profil* (1926), for example, images a head in raking three-quarters profile, sliced off between the forehead and the chin, which appears to the left of the composition as an assemblage of five shaded areas (a tiny neck, an undulating cheek and forehead, a wedge-like nose, and two scrolls representing the hair). This abstracted physiognomy is juxtaposed directly against eight stenciled notations, including a zero and a minus sign (possibly seen in reverse through the glass of a door or window) and a group of other elements, including what appears to be a part of a mirror and five blinds. Mirroring, reversal, and the now-you-see-it-now-you-don't binarism of the blinds, all contribute—both literally and conceptually—to Léger's switch-like visual rhetoric that constantly shuttles between alternatives: of recognition, abstraction, and doubling.[33]

Oursler responds to the new formal complexities of overlay and exchange between the urban environment, its infrastructure, and the machines that punctuate it granted by Léger's post-Cubist compositions. Like Léger, he is especially interested in the arrangement and coordination of objects, including faces, by flatness and contour. The prevalence of circular objects in Léger's images, whether motifs like the bagels or biscuits and upturned hats that surround another face in hard profile in *Composition à la main et*

aux chapeaux (1927), or the spots, dots, bolt-heads, and wheels that punctuate both this work (one is even included on the cheek of the face) and many others of the period, reinforces the central tenet of the artist's equalized distribution among objects. No matter whether the circle relates to a zero, a rivet, a porthole, an apple, or a face, he insists, the shape signifies as a specific object locked into a formal arrangement within

 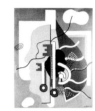

Tony Oursler
Untitled, 1999

Fernand Léger
Nature morte (Les clés), 1928

which its emotive signification, prompted by any form of identification that is not literal or presentational, is muted or irrelevant. Oursler, too, takes up with the circular motif, but unlike Léger, for whom the face is often a classicizing throwback seen in the flatness of a *profile*, it is the face itself apprehended in simplified, caricatural, or popular cultural forms—whether a smiley face, an anime disk, or a blob-head—that inhabits his graphic circularity. The circle of the face becomes an allegory for its self-referring circuitry and the switch-system of media simulations that turns it on and off.

We are now in a better position to understand the enduring correlation in Oursler's work between flatness, faces, and a wide range of contemporary technological conditions: the protocols of video and the constitution of the TV broadcasting apparatus; and the interfaces among TV and its audiences, and the psycho-social conditions of viewership. "The viewer," he writes in "Phototropic" (1990), "sits as a nullity, hypnotized by the light and synced to the electromagnetic waves of the Utility of Television ... While under the influence of the Utility, the viewer manifests one of the predominate signs of schizophrenia: the inability to identify the perimeters of the body or to perceive the point at which the body ends and the rest of the world begins."[34] Viewing bodies surrender themselves under the dull aura of TV. They become unending surfaces whose corporeality is defeated by their mesmeric

33. This discussion of Léger draws on my essay "Faces, Mask, Profile: From Affect to Object in the Work of Henri Matisse and Fernand Léger," in *Contemporary French Civilization*, special issue on "Visual Culture," eds. Michael Garval and Andrea Goulet, Summer/Fall 2004, vol. XXVIII, no. 2. p. 176–191.

34. Tony Oursler, "Phototropic," in *Illuminating Video: An Essential Guide to Video Art*, eds. Doug Hall and Sally Jo Fifer, Aperture, New York 1990, p. 489.

stupefaction. The knobbly surfaces of the couch potato are reduced to apparitions of their own peel, a spiral of thinness that seems to have no termination. As ever, Oursler's observations are not staged as straightforward social critique, and his targets are not primarily framed by the content level of commercial culture— whether advertisements or gender constructions. Rather, he takes up with pseudo-narratives that are themselves organized by some of the generic inflections of TV and celluloid culture. What results is a kind of sci-fi or horror-flick vision of the viewer's relation to the centripetal forces of the screen. This is, at the same time, a ghost story as "symbolic species identification is evoked within the viewer … to induce the out-of-body experience."[35] The figure governing all this is not, therefore, an embodied spectator, but a being whose input/output system has been recoded as a surrogate under the dispensation of "Electronic Animism."

35. Ibid.

Perhaps the key focal point in the distribution system of social flatness administered by TV is the actor, a subject position to which Oursler attends not only in its formalized production conditions, but also as a reference point for considerations of self-performance and historical agency which continue in his recent work. It is not surprising, therefore, that Oursler subjected the characteristics of the onscreen persona who organizes the enfabulation of television to caustic recallibration in the poetic reverie of reductions set out in "Phototropic." Beginning as a mere dot or mote of punctuation, the small black point that stops and apportions the frames of writing, the actor is also "a hole with language coming out of it" and the personification of figural flatness at the front of the TV screen: "Anything in the foreground."[36] It is only by understanding the primacy of these constrictions, Oursler's version of the ultra-flat, that the other dimensions of the surrogacy system on which it depends can be apprehended. The actor as "effigy" is the shaping force for receptions of TV that give the appearance of palpability and variation; he is not a "mirror" but a surrogate for processes of flat reflection; the actor is not a manifestation of "anything that moves" or "any evidence of life," but a sign of the

36. Ibid.

reduction of these alls; the actor is not an agent of "empathy," but an engineer of fleeting, superficial attractions. The actor is Frankenstein, but only as the emblem of a clumsy, mechanized, pseudo-humanity.

In a challenging discussion of Oursler's earlier work and his first projection pieces, Tony Conrad and Constance DeJong question the relations they pose between spatial and subjective space and their attendant arbitration between character and stereotype, reality and fantasy. Conrad points to a crucial dichotomy in the early, single-channel videos, such as *EVOL* (1984), between what he termed a "completely elaborate universe of flats and sets in a spatial narrative," on the one hand, and a "sort of verbal and actional universe," on the other.[37] In some sense the video projection pieces complete the uncertain journey of the background prop to the front of the image and then outside it, and one understanding the rhetoric of captivity and imprisonment that emanates from so many of Oursler's rag doll figures can be seen as a response to this continuity, as protagonists once trapped inside a medium are now incarcerated in any number of social or moral dilemmas. Dishing out raillery and "paranoia" (Oursler's term),[38] the limply clothed dummies, their garments hung on sticks or tripods, seem utterly unencumbered by corporeal volume, and incautiously, sometimes churlishly, unaware of its loss. This bodily evacuation is matched by the ghost-like flatness of the participants in Oursler's projects, who are "included" as "hallucinations," as Conrad notes. Oursler's dummies and mannequins, modeled in part on the artist's early fascination for the scarecrow figure, belong to an extended tradition of flat, uninflected emblematizations of human corporeality which includes early modern automata, the masks of James Ensor, the mannequins and tailor's dummies of de Chirico, and several Surrealist photographers and object-makers, and the reduced or abstracted "personages" of Joan

37. "A Conversation Between Constance DeJong and Tony Conrad," in *Tony Oursler: Dummies, Clouds, Organs, Flowers, Watercolors, Videotapes, Alters, Performances and Dolls*, exh. cat., Portikus, Frankfurt am Main 1995, p. 6.

38. "Oursler has described [his dummies] as 'the most paranoid'"; cited by Friedermann Malsch in "A Kind of Primal Horror: On Dummies, Clothing and the Absence of the Body in the Works of Tony Oursler," in *ibid.*, p. 31.

Miró. With this genealogy in mind it is clear that Oursler's work is also linked to the discourse of biomorphic abstraction and its facialized conditions so prevalent in his recent exhibitions, as we will see below.

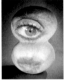

Tony Oursler
Cyc, 2003

Joan Miró
Person Throwing a Stone at a Bird, 1926

39. See, for example, Sander Gilman (ed.), *The Face of Madness: Hugh W. Diamond and the Origin of Psychiatric Photography*, Brunner/Mazel, New York 1976.

Emil Nolde
Masks, 1911

Tony Oursler
Handsome, 2003

40. Tony Oursler, email to the author, March 17, 2008.

At the same time, Oursler takes up with another history for the emotive face arising from the legacy of early psychiatric and psychological photography and the alliances they brokered between physiognomy, criminality, and insanity.[39] For Oursler, the face is always an empathy-testing apparatus generated by an engulfing media culture. If the correlation of psychology with facial photography in the later 19th century represents an inaugural moment in this technological journey, its two key way stations are the covert empathetic surrogacy negotiated (or foreclosed) by the dummy and the mannequin, and the emotional exchange system of tv itself. The contemporaneity of the face, in this vision, is constituted by its role as what Oursler terms a "mood machine" or "fantasy extender."[40] The artist's facial manipulations offer a commentary on these exigencies brokered by caricatural distortion and the resultant "noise" of expanded and contracted features; and informed by his longstanding interest in "testing" itself, especially in the Minnesota Multiphasic Personality Inventory (MMPI), one of the most frequently used personality tests in mental health, which was first published in 1942, at the beginning of the tv era.

But Oursler's characterological reductionism doesn't stop at the threshold of the type or the cliché. As Conrad and DeJong suggest, Oursler's work is marked by his unstinting capacity to facialize and animate even the most obdurately intangible of non-geometric forms. If, for Conrad, "almost any tawdry bit of fluff can become a protagonist,"[41] DeJong pushes the matter even further toward immateriality, observing that "a character can be a little piece of light that zooms around."[42] While Oursler's protagonists become reduced, even ineffable, both the activity of projection that animates them, and the receiving surface or volume they inhabit, are subject to analogous forms of diminishment. This is nowhere better evidenced than in the series of cloud pieces commenced in 1994, in which suspended masses of synthetic cotton furnish ephemeral and physically dissolute zones for phantasmatic, three-dimensional projections of flatness, giving rise to pseudomorphs that confront the viewer "as a ghost would."[43] Using gestures of ironic presence, Oursler strikes back against the whimsy of that reading of corporeality into clouds and crumbling walls observed by Leonardo and others, substituting media projection for its imaginative variant. The persistence of references—both by Oursler and his critics—to the overlay between animated forms and the regimen of ghosts and ghouls suggests that the spectral has become a delivery system for the haunting of flat form, the very place, in fact, where the blob and the phantom, the sheet and plane, converge. Oursler might have concurred with the young Walter Benjamin, who noted in 1919 that, "In its present state, the social is a manifestation of spectral and demonic powers."[44]

The intersection of impalpability and presence that constitutes

Period image of TV in a living room in the 1950s or 1960s

41. "A Conversation Between Constance DeJong and Tony Conrad," p. 6.

42. Ibid.

43. Elizabeth Janus and Paolo Colombo, "Some Notes on recent Work by Tony Oursler," in *Tony Oursler: Dummies, Clouds, Organs, Flowers, Watercolors, Videotapes, Alters, Peformances and Dolls*, p. 22.

44. Walter Benjamin, "World and Time," in *Walter Benjamin: Selected Writings, Volume 1, 1913–1926*, eds. Marcus Bullock and Michael W. Jennings, Harvard University Press, Cambridge, Massachusetts 1996, p. 227.

this ghosting of form has other sites—and consequences—however, predicated on the shifting nature of the collisions or mergers, overlays, and transparencies that underwrite it. One location is in the body itself, whose skin or surface envelope is, of course, coupled with an invisible interiority, which Oursler used as another projection platform in his breakthrough work in *Dummies, Clouds, Organs, Flowers, Watercolors, Videotapes, Alters, Peformances and Dolls* in 1994–1995. As "K" puts it in the dialogue that emanates from *Organ Play #2* (1993), the "organ" is "the place where the outside passes through to the inside."[45] Another site arises from Oursler's persistent suggestion that the metrics of invisible bodies are recoded at the level of the technological by virtue of their resemblance to "the transparency inherent in electronics."[46] An extension of the same kind of logic is responsible for another outcome of Oursler's longstanding interest in schematic or diagrammatic heads, from clichés, cutouts, and caricatures, to the ubiquitous smiley face. This is the signal elision by the artist of the TV screen and the lowest common denominator of facial demarcation in the form of the three simple circles or dots in the "negative" and "positive" versions of *The Reflecting Face*, Oursler directed his pointed ironization of the pathetic fallacy to geometric forms in a number of pieces, most literally and extensively in *Diamond Head* (1979), in which the leading "characters" are, as the title suggests, simple, diamond shape cutouts which stand in for a stereotypical soap-opera cast. But Oursler's endemic characterological flatness is not simply harnessed to and engendered by the artist's abundant satirical whim. Instead the literal, flat, stick-like characters of Oursler's "Alters" also look over to the simplified, but pluralized, assemblages of selves, with their serially specific attributes, common in clinical Multiple Personality Disorders, alluded to in *Judy* (1994).

As these notions of spectral, technical, and somatic flatness accumulate, and as they collide with the man-machine couplet of the TV actor, another key proposition in Oursler's discourse of faciality emerges. For the monstrousness and inhumanity identified by Wittgenstein as the possible consequence of a deficit in mimetic understanding returns in yet another form in the extended sequence of biomorphic facial surrogates that has dominated his recent reckoning with the body. The new iconography is present in the frog-like facial assemblages of bulging eyes and melon-slice mouth in *Transformeds* (2003) and *Over & Out (Blue)* (2003, p. 57), and in drawings where this goofy abbreviation is further truncated, such as *Neg Leg* (2003) and *Untitled* (2003). It is reworked in the eye- and mouth-bearing painted collages made in 2004 (such as *Twiced*, 2004; *Non*, 2004, p. 67; and *Crimsac*, 2004, p. 71); refigured once more in a series of fiberglass panels punctuated by inset miniature monitors (*Ether*, 2006; *Ruby*, 2004; *Daub*, 2004; *Digo*, 2004; *Splotch*, 2004; p. 92–95); and given its most recent inflection in the more complex "paint-splash" configurations from 2007, which are named for their color associations (including *Purple Ideation Exposure*, p. 109; *Invisible Green Ink*, p. 110; *Bluerealisation*; *Red "Love Hurts" Laboratory*, p. 105; *Emanate Orange*; *Pink-too-long*; and *Black in Black out*; etc.).

The journey that gave rise to these series was occasioned not by the artist's engagement with another installment of somatic reduction, but by his attention to the social appearance of the television set. Oursler responded to a generational shift in the ways TV has been lived with, from its obsequious regulation of the familial unit, and virtual absorption as a family member, in the 1950s and 1960s, to its latter day reincarnation as an emblem of surrogate vivacity—something, he suggests, that resembles a kind of "techno-pet."[47] The physiognomy of the TV-techno-pet emerged under the pressure of strategic reductions and allusions based on an imaginary marketing model for a virtual menagerie. As it would speak (of course), with the whispers and informalities of pillow-talk, trading nick-namey stylizations, and as it would see and be seen in doses of looking and blinking, it would have to have eyes (or one at least) and a mouth (or some part of one). But it didn't need to engage in transactions of smell, and so would have no nose. It would need to

45. Dialogue for *Organ Play #2* (1993), reprinted in *Tony Oursler: Dummies, Clouds, Organs, Flowers, Watercolors, Videotapes, Alters, Peformances and Dolls*, p. 23.

46. Malsch, "A Kind of Primal Horror," p. 31.

47. Tony Oursler, in conversation with the author, February 18, 2008.

be seductive, but in an empathetically generalized way, so its formal appearance would conduct its desirability through a trace of the Venus of Willendorf and a hint of the maternal breast-form. It would be therapeutically hi-color and almost glossy in appearance; and it would be self-perpetuating, even embarrassing, in its "behavior." The talking-pet faces that result are precipitations sprung from cyber-space. The response to the "telly" that eventuates from all this is "tubby"—in the sense that it bulges with convivial or mindless abstraction—but remains flat by several other measures, most obviously under the technological dispensation of the flat-screen, but also according to that logic of facialized thinness in which the switch between sense and nonsense, real and virtual, living and dead is cunningly suspended.

These facial compounds act as enframement devices for another round of allusive confusions, as the face becomes an arena for erotic inscription and then a dissident sexual organ. Most apparent in several works from 2003 (such as *Baby)*, its devouring appetites, tactile drives, and morphological promiscuity gather up the sexual energies and appearances of the body it fronts and heads. As we have seen time and again, however, Oursler does not over-commit his free-range similitudes on the model of a visual rhyming couplet—combining face and female breasts and genitalia in the manner of René Magritte's *Le Viol* (1934);[48] or acceding to the still more prurient re-orderings of the Chapman brothers' *Zygotic acceleration, biogenetic de-sublimated libidinal model (enlarged × 100)* (1995), a fused set of manipulated child mannequins whose facial orifices are replaced by genitals, or *Fuck Face* (1994), in which a toddler wearing red sneakers is given a dildo for a nose and a sex-doll orifice mouth. He is interested, instead, in how the face is fed back through the media as a sex machine—the object of a masturbatory fantasy that takes over from those heads detached from bodies given to us as voyeuristic fetish objects by the editorial protocols of TV. These faces, too, he suggests, are technologically induced generators of fantasy that perform their own sex acts on the viewer.

In three of his most recent exhibitions, *Blue Invasion* (for the

48. For a discussion of Magritte's *Le Viol*, see Robin Adele Greeley, "Image, Text and the Female Body: Rene Magritte and the Surrealist Publications," *Oxford Art Journal*, vol. 15, no. 2, 1992, p. 48–57.

Sydney Festival, January 7–24, 2006), *Ooze* at Lehmann Maupin (February 17 to March 24, 2007), and *dum-dum, metalbreath, wadcutter* (Emi Fontana Gallery, Milan, May 28 to July 28 2007), Oursler raises the stakes of his multivalent faciality to a flashpoint. In *dum-dum, metalbreath, wadcutter*, this move is managed through a daring iconographic innovation in one of the artist's most overtly critical installations, as the sculptural platforms and accompaniments for his projected personae are rendered—with appalling matter-of-factness—in the streamlined shape of bullets: long-range sniper bullets, common pistol rounds, spent "mushroom" bullets, what the artist calls "bullets-in-waiting," and mutilatingly efficient hollow points, which expand into the body on impact. *Blue Invasion* is the telescope to *dum-dum*'s microscope, moving from singular units of violence and warfare to cosmologically-scaled conflict, from the synecdoche of itemized munitions to the impalpable metaphorics of *Star Wars or War of the Worlds*. Sydney's Hyde Park became a staging ground for alien sightings as spectral physiognomies appeared in the trees along with a slime-green meteor cratered with another round of squirming faces. Oursler recalibrated the face-landscape relation here by offering it an impossibly deviant extraterrestrial dimension. The skin, the color, the geology, the language, and the actions of these aliens are conjured up in a remarkable compound of in situ sounds and images, then reformatted in a series of small books, each titled after a color, that reproduce alien diaries, charts, diagrams, speculative meditations, and drawings.

In addition to summarizing his own interest in the representation of color, addressed, as we have seen, in various allusions to TV test-cards and color charts, Oursler's *Yellow, Red, Blue, Orange, Green, Black* and *Purple* books, and the color-coded laser-cut aluminum panels in *Ooze*, take us back to Wittgenstein, who wrote his own *Blue* and *Brown Books*, and whose last work, *Remarks on Color*, outlined an eccentrically incisive critique of the phenomenological notion of color dominant in Western thought since Johann Wolfgang von Goethe's *Zür Farbenlehre (Theory of Colors*, 1810). Oursler peppers his own spectrum commentaries with the popular associative logic that underwrites the Romantic theory of

color: "I'm blue I'm very sad I have SAD, Seasonal Affective Disorder," or "baby boy gets baby blue power" (*Blue*); the "red light district" or "it's your red letter day" (*Red*); "For the wounded a purple heart awarded after recovery" (*Purple*). But even as he advances these color-coordinated formulae, the colloquially speculative and confessionally ironic rhetorics in which they are delivered break their analogical messages down—so that the poetic reverie of Andrew Marvell's "green thought in a green shade," for example, is made over as "Green" becomes "a mean and enviable stream of thoughts flowing in my mind behind the right and natural and lush color" *(Green)*. Layered with arcane scientific references, wavelength numerology, and UFO folklore, Oursler's ET color theory becomes a discursive net for the entrapment and sifting of alien incognitos.

For Oursler, aliens are figures of a radically improbable alteriority that displaces the residually humanist metrics of otherness that were so powerful in the art and critical worlds of the 1970s and 1980s. Detaching himself from the urban psychodramas of his earlier projected figures, Oursler's latest protagonists are embedded in the ultra-biomorphic, splash-shaped panels of the *Ooze* exhibition, which camouflage color appearance in its spectral points of origin. No longer apprehended through the logic of peepholes or portholes punctured through a surface according to which one imagines a humanoid presence "behind" the panel or "inside" a screen, the roving eyes, mouths, lips, and other facial parts co-present in these works now seep or ooze from their "supports" edged not by apertures but by fuzzy aggregates whose computer-generated contours morph in syncopated rhythms with both the complex outlines of the splash-like panels and the movements of various puckered lips, raised eyes, bared teeth, and so on.

Oursler's commitment to UFOLOGY, extraterrestrial lifeforms, and speculative xenolinguistics is filtered through a matrix that joins radical aesthetics with philosophical inquiry and vernacular metaphysics. One point of commencement for this emerges as Oursler infiltrates himself into the subject position of the alien, most obviously in the photographs that represent his face painted with other-worldly colors and the pseudo-autobiographies of the

booklets. Wittgenstein offered a less theatrical version of a similar sentiment, once remarking that, "I feel myself to be an alien in the world. If you have no ties to either mankind or to God, then you are an alien."[49] To these confessions of alien self-identification we should add two contexts, one philosophical, one aesthetic, that clinch the subtle imbrications between ET and IT, optical and semantic color, hallucination and para-reality to which Oursler's work, and some of Wittgenstein's writing, alludes. Perhaps Derek Jarman was right after all when, in

49. Ludwig Wittgenstein, cited by Ray Monk in *Ludwig Wittgenstein: The Duty of Genius*, Penguin Books, London 1990.

a much-criticized gesture, he introduced a space alien into his film *Wittgenstein* (1993).[50] For Wittgenstein struggles, albeit fleetingly, with the famous thought experiment about the possible existence of "logical aliens" proposed by Gottlob Frege. Could there be, Frege mused, a class of intelligent beings whose rationale capacities operate according to different laws of logic than those supplying human reason? While Frege contended that the existence of such beings was physically impossible,

50. For more on the film, see Derek Jarman and Ken Butler, *Wittgenstein: The Derek Jarman Film*, British Film Institute, London 1993, which includes an introduction and script by Terry Eagleton, discussion by Jarman and Butler, and an array of film stills.

Wittgenstein, like Oursler, flirted with the implications of non-human language (as in his elliptical remark that, "If a lion could talk, we could not understand him"[51]) if for no other reason than to learn from the logical aporia opened by the very process of speculating on the unknown.[52]

51. Ludwig Wittgenstein, *Philosophical Investigations (1953)*, Blackwell, Oxford 2001, p. 190.

In one of his most teasing (and Wittgensteinian) pronouncements, Oursler offers a key for the interpretation of the work that makes up *Blue Invasion* and *Ooze*, providing at the same time one of those moments of "special practice and training" that Wittgenstein associates with dimensions of representation that are less (or

52. See Clevis R. Headley, "Wittgenstein and Frege on Madness: Searching for Logical Aliens," in Paul Weingartner, Gerhard Schurzand, and Georg Dorn (eds.), *The Role of Pragmatics in Contemporary Philosophy: Papers of the 20th International Wittgenstein Symposium, August 10-16*, Kirchber am Wechel, vol. 1, text 395.

more) than three: "The artist or the artwork," he writes, "is the alien, and the viewer is the earthling or the one I'm trying to communicate with."[53] The artist-alien-artwork compound takes its

place in a genealogy of aesthetic reckoning one origin for which Theodor Adorno attributes to Hegel: "In one of the most remarkable passages of his *Aesthetics*, Hegel defined the task of art as the appropriation of the alien."[54] Adorno himself is, perhaps, the most articulate legatee of this tradition, developing in his own *Aesthetic Theory* an almost unfathomable dialectic worked out between the formal conditions of the artwork and the alien heterogeneities on which it depends: "By its mere existence, every artwork, as alien artwork to what is alienated, conjures up the circus and yet is lost as soon as it emulates it. Art becomes an image not directly by becoming an *apparition* but only through the counter-tendency to it. The pre-artistic level of art is at the same time the memento of its anti-cultural character, its suspicion of its antithesis to the empirical world that leaves this world untouched ... Important artworks," he concludes, "nevertheless seek to incorporate this art-alien layer."[55]

53. This sentence appears as the caption to a full-page photograph of Oursler posed against two outline figure drawings in Karen Wright, "Close Encounters: Tony Oursler's Alien Invasion," *Modern Painters*, March 2006, p. 72.

54. Theodor W. Adorno, *Aesthetic Theory*, trans. and ed. Robert Hullot-Kentor, University of Minnesota Press, Minneapolis 1997, p. 339.

55. Adorno, *Aesthetic Theory*, p. 108. Adorno develops these ideas throughout this study, arguing, for example, that "the subject only becomes the essence of the artwork when it confronts it foreignly, externally, and compensates for the foreignness by substituting itself for the work" (p. 346). Thinking of the recall of one's earliest childhood moments, Adorno notes elsewhere that, "the I which one remembers, which one once was and potentially is once again, becomes at the same time an other, an alien, to be detachedly observed"; later in the same text he expands on his notion of "loving the alien," observing that: "The reconciled condition would not annex the alien [Fremde] by means of a philosophical imperialism, but would find its happiness in the fact that the latter remains what is distant and divergent in the given nearness, as far beyond the heterogeneous as what is its own." *Negative Dialectics*, trans. Dennis Redmond (2001), http://www.efn.org/~dredmond/ND2Trans.txt

II

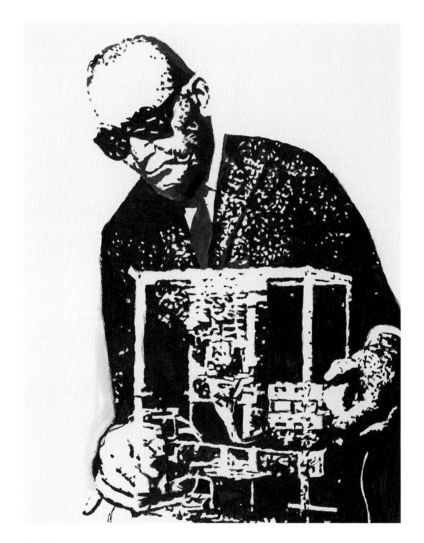

Tune Mort, 2003
Acrylic on paper

TV-Studio, 2002
Installation view

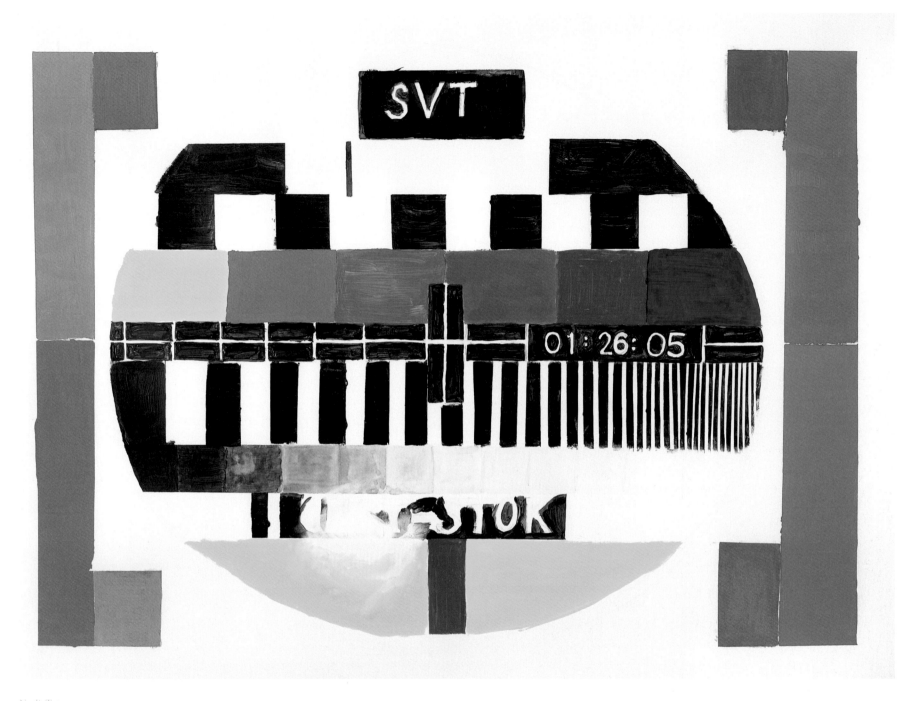

Nordic Test, 2002
Acrylic on paper

Frequency Spectrum, 2002
Wood, paint

Freqlot 2, 2002
Acrylic on panel

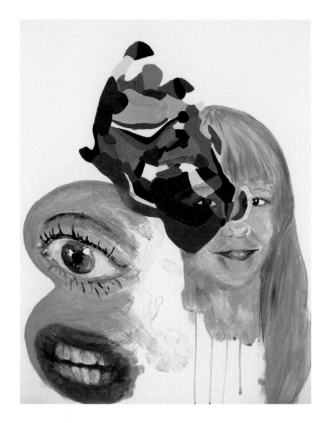

Ob TV!, 2003
Acrylic on paper

Cyc, 2003
Aqua-Resin, video

Visitation, 2003
Acrylic on canvas

Handsome, 2003
Acrylic on paper

Untitled, 2003
Acrylic on canvas

Baird vs Future, 2004
Acrylic on paper

Reptamation, 2003
Acrylic on canvas

Over & Out (Blue), 2003
Acrylic on paper

Neg Leg, 2003
Acrylic on paper

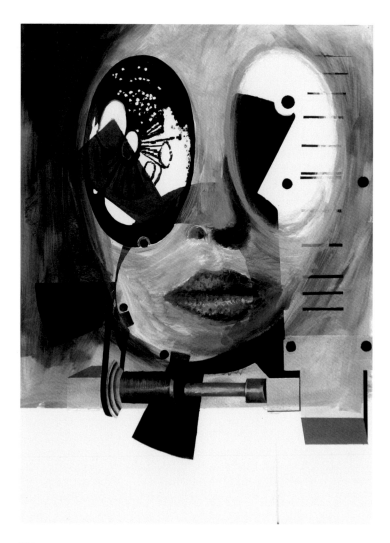

Chine, 2003
Acrylic on paper

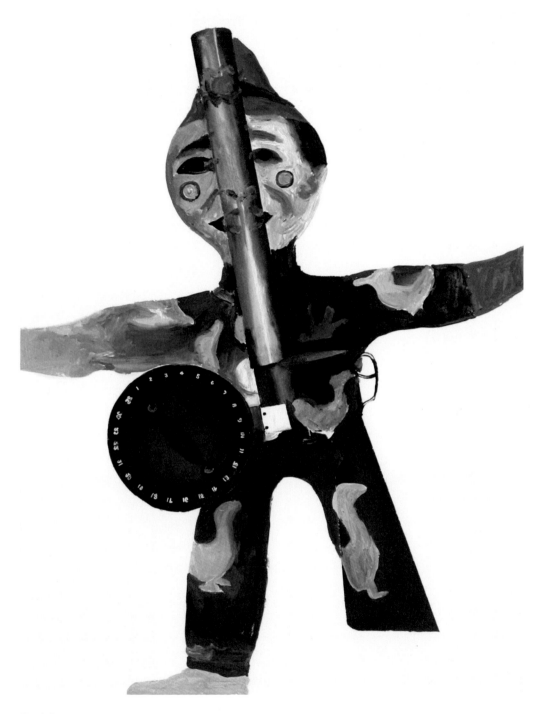

Dough Boy, 2004
Acrylic on paper

59

Untitled Remote with Doll
Acrylic on paper

Compression, 2002
Plexiglas, Sony VPL-CS4 projector, metal

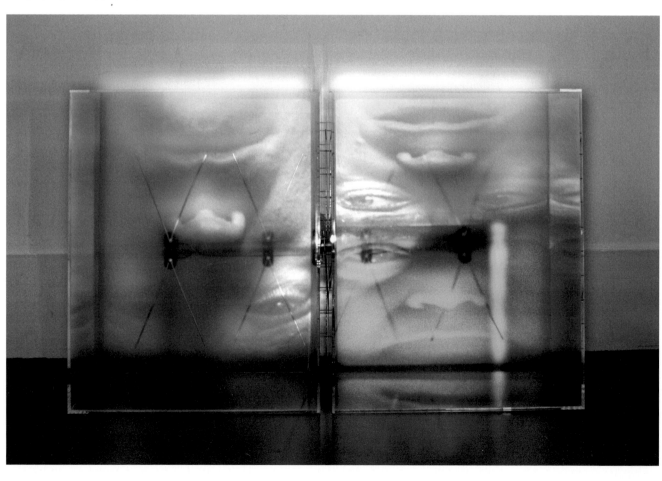

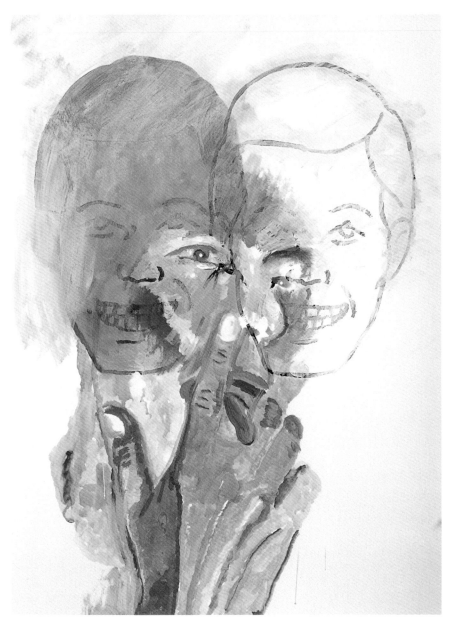

Untitled, 1999
Acrylic on paper

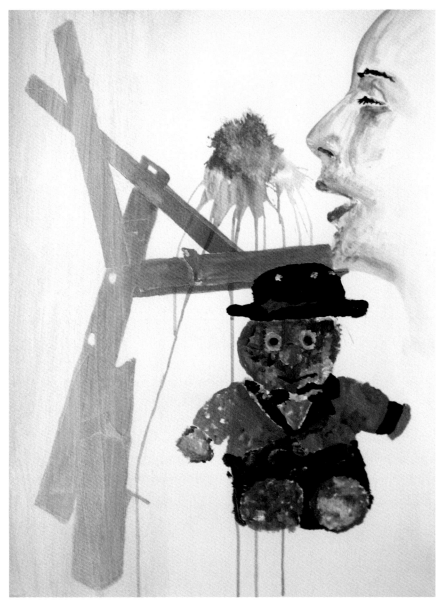

Unkie, 2002-2003
Acrylic on paper

Within the artwork, partially visible text reads:

15 Effect on the unattenuated
strength at one mile by
ngth of the radials The radial
specified in wavelength
for 113 radials and the

Pattern America, 1998
Acrylic and marker on paper

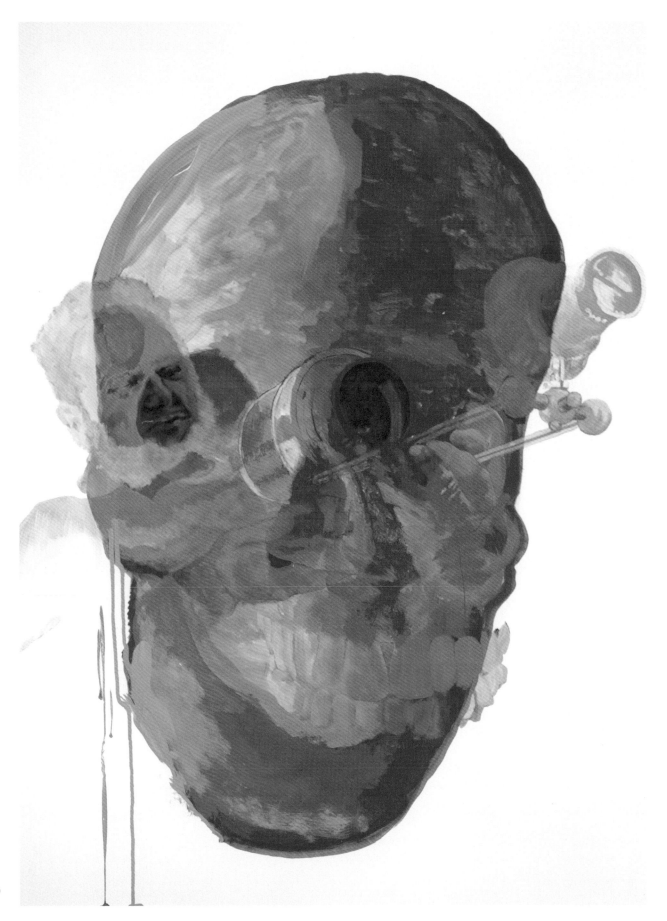

Redskull Experiment, 1999
Mixed media on paper

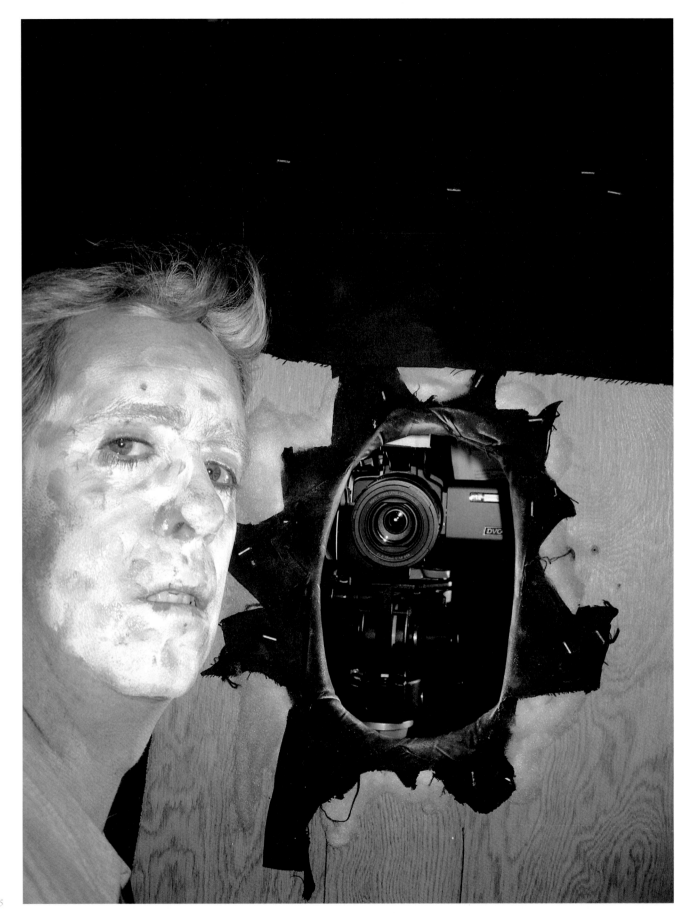

Video production still, 2005

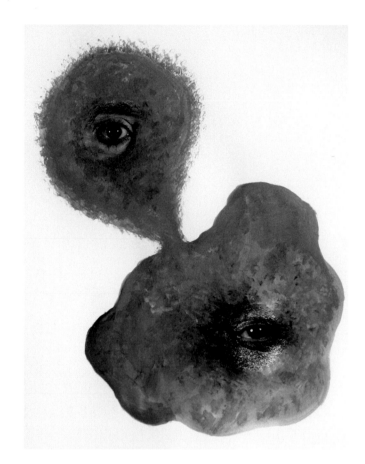

Twiced, 2004
Acrylic and collage on paper

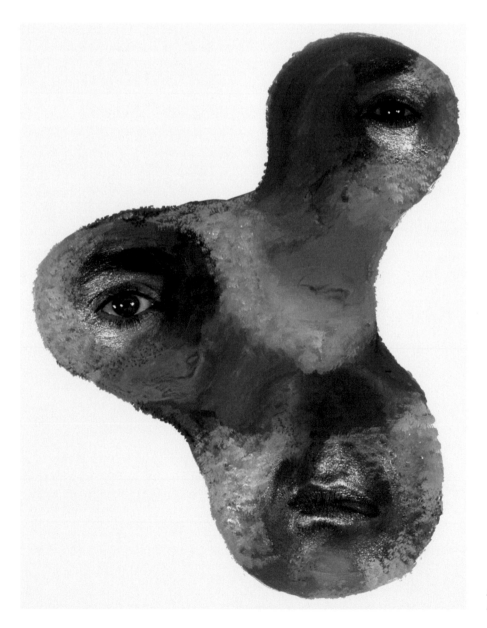

Silv, 2004
Acrylic and collage on paper

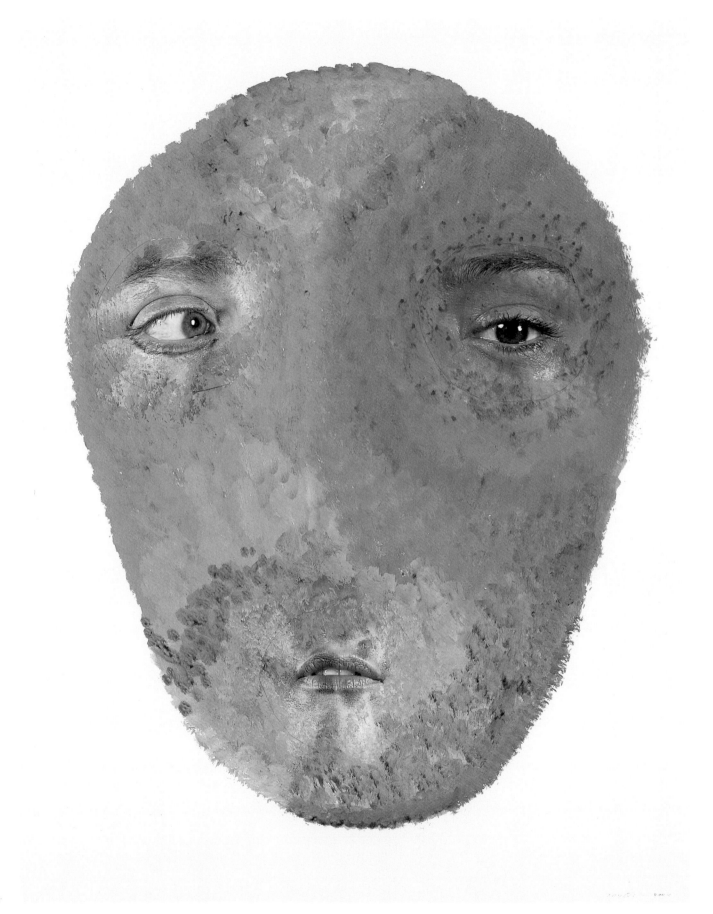

Non, 2004
Acrylic and collage on paper

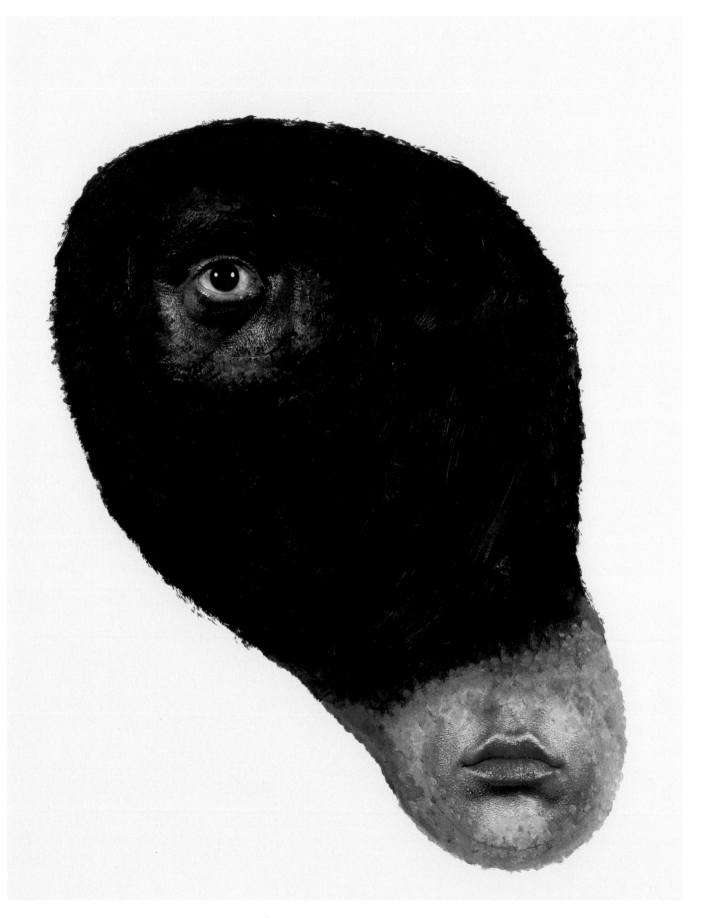

Metalla, 2004
Acrylic and collage on paper

Spectra, 2004
Acrylic and collage on paper

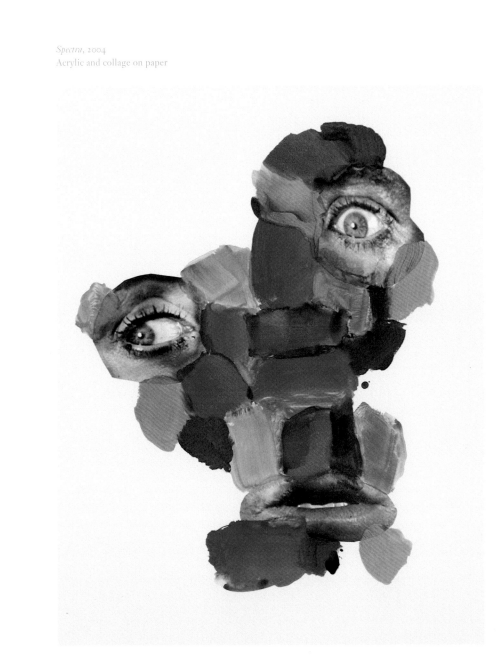

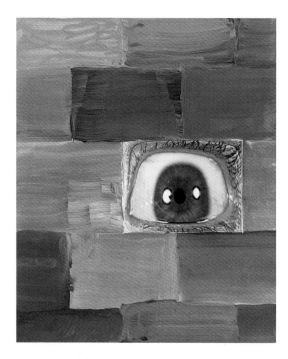

Gold Walk 2005
Acrylic and collage on paper

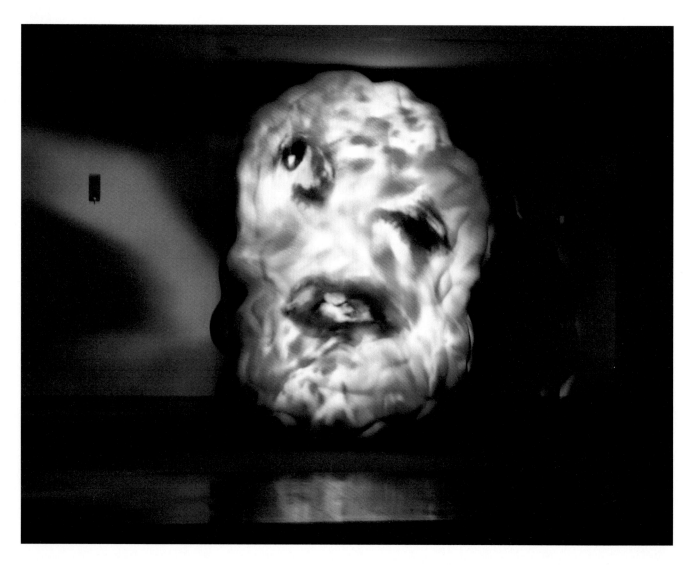

Climaxed, 2005
Video installation, Aqua-Resin

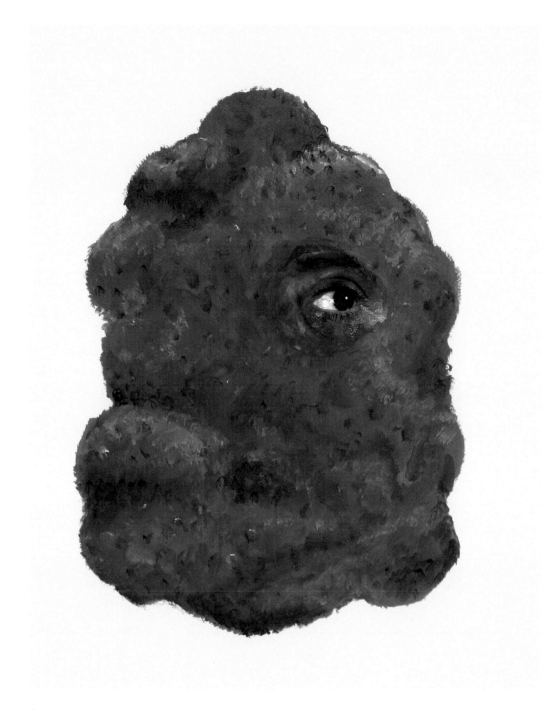

Crimsac, 2004
Acrylic and collage on paper

71

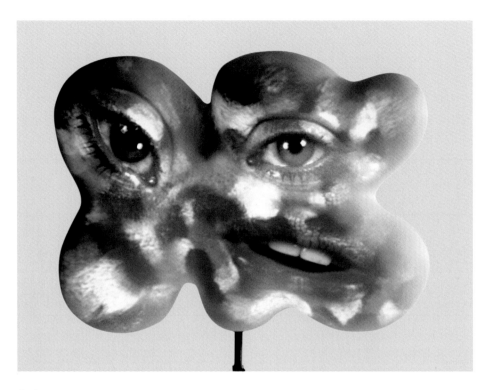

Goody, 2004
Aqua-Resin, video, metal

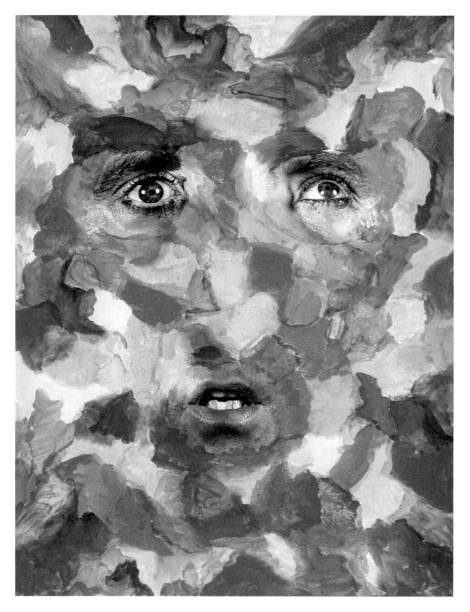

Colost, 2004
Acrylic and collage on paper

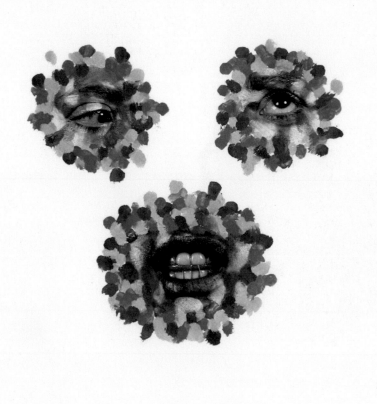

Ogled, 2004
Acrylic and collage on paper

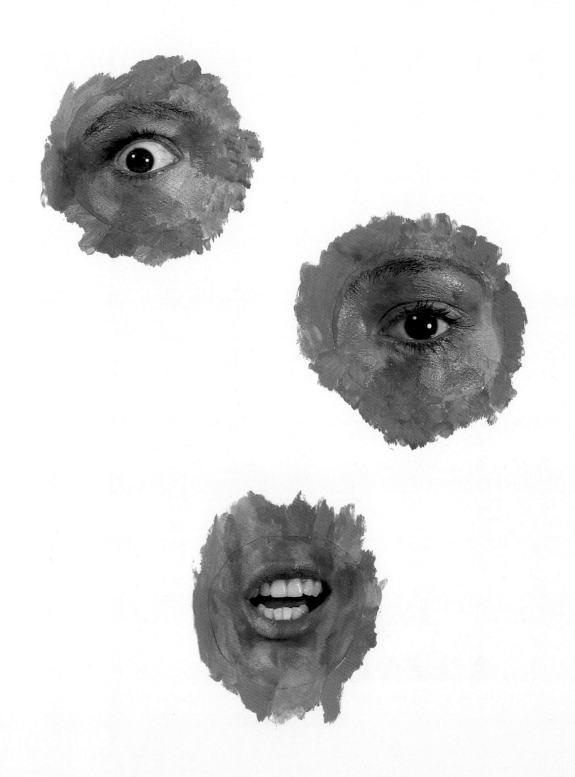

Cla, 2004
Acrylic and collage on paper

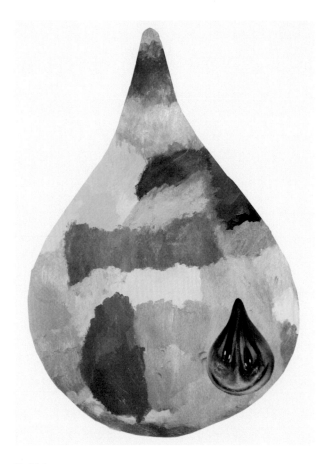

Production still for *Bell Deep*, 2005

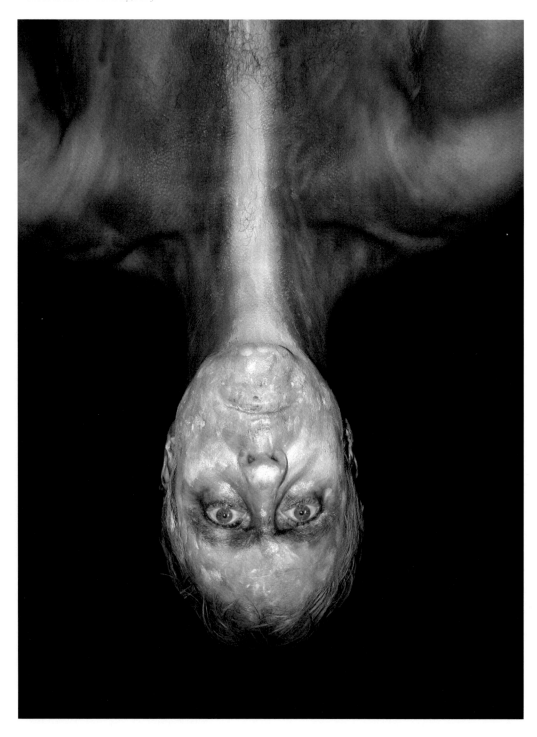

Untitled, 2003
Acrylic and collage on paper

Untitled, 2003
Acrylic, graphite, and
ballpoint pen on paper

Interview Lynne Cooke and Tony Oursler

LC – When we first started discussing this project, it was going to be a book on your drawings. Looking at the proposed selection of plates now, it seems that the focus has shifted a lot, perhaps in response to your very broad, or encompassing, definition of drawing.

TO – Yes. In fact it's not drawing at all. If it's anything, it's really painting—because there's more paint involved than pencil or pen or whatever … [They laugh] I don't think the word drawing is going to appear in the title, but I like the term "drawing" because it implies something that, in some way, is temporal or extemporaneous.

LC – You said in a previous interview that you think of drawing as open, as somehow not finalized, whereas painting, by contrast, often suggests something resolved or finished. And yet as I look back over your work from the past three decades there is very little that could be described, in conventional terms, as drawing. It seems that, for you, there's no hard and fast boundary separating drawing from almost everything else you do.

TO – When, recently, I was trying to imagine what a drawing was, I started to think of it as a chain of events. In a way you could say it starts at the wall when I plug something in that connects to the electricity through a wire. As the electricity flows into the artwork, it starts a disc, which is like a big spiral of light and mirrors, spinning, and that comes out onto a screen. This echoes the process of shooting with a camera, the product of which, in turn, is run through a computer. Imagine the paths and conversions the image takes inside, while I crunch and warp it with the program called the Mesh Warp, then further process it in some way. Fill in the blanks … my hand writing a script, a performer reading it, then speaking … You could even say that during the shooting the camera swallows a cone of light that is captured, written onto a chip inside the camera, and then written onto the tape or put onto the disc, and then another line—another wire—takes it into the computer … That's the drawing: all those decisions, those marks of decision making, those flows of electricity, of information. When the work is finished it's frozen, at least to some

degree, yet it's still alive somehow: it's talking and moving and gesticulating.

To talk about drawing, at this moment in time, is a little absurd, because in the 1970s artists like John Baldessari were already talking about camera movement as a kind of drawing device. That's where I'm coming from in these recent pieces—the splatter video/paintings. Within the vast information flow that can no longer be contained, drawing is that process of trying to connect it and harness it. Does that make sense?

LC – Yes, absolutely. Where does this idea of drawing first manifest itself in your work? You have talked about 1991 as a kind of Year Zero, a time when you rethought your practice pretty thoroughly. Soon after that, you abandoned the making of single-channel videos and created the first of the dummies. Was that also the moment when the first works on paper appeared?

TO – Well, no, for years I had painted for media space, for the camera, in order to produce tapes and installations. There were also pictures that did not move, but at that moment they took on a conceptual focus that they hadn't had before. It involved the death of a certain kind of pictorial space, which I think of as the classical space that one peers into from a distance. From then on I tried to make 2-dimensional representations that worked in new ways. Each series was made with a different experiment in mind. First were watercolors, the *Closet Paintings*—obviously a pun on being a closet painter. They were portraits of people's spaces, or mindsets, by reference to what they had in the medicine cabinet or under the sink. Before that, whether I was working on paper or painting, I was in some sense making classical painting. Before 1991, when the works were not studies, there was always a disconnection from the installation work. After that, there was more of an attempt to connect the wall works to the thinking behind the installations and tapes—and to push them in that direction. For example, there were lenses in those constructed wood hex paintings based on the Pennsylvania Dutch's way of marking their architecture with protective signs. And then there were also works

on cloth, like the piece that says "Model Release Form" at the top. I was really interested in the way people sort of signed over their ownership of intellectual property for money; it almost involves some kind of contemporary slavery. Since 1991, those ways of opening up beyond conventional pictures have continued.

LC – Do you see your work dividing loosely into two main bodies, or types, of practice? On the one hand, a great deal of your work involves working collaboratively, or working with other professionals whom you hire because of their specialized skills. On the other hand, when you're making smaller works on paper, the situation seems utterly different in that it involves just yourself. Drawing is often traditionally described as a more private activity. It's personal, not simply because it's made by one person working in isolation but because, if it's small in format and scale and intimate in touch as was traditionally the case, then it's viewed by a solitary spectator. That suggests a one-to-one engagement; a pretty direct transmission from the maker to the receiver. Does this distinction between these two types of working hold up in your mind?

TO – Absolutely. That kind of intimacy suggests a certain kind of symbiotic space—which is probably one of the things that always draws me back to that way of working. As you say, that kind of private, handmade space offers a unique place to be with the viewer. There's a beautiful book by Philip K. Dick—I think it's called *Galactic Pot-Healer*—which contains some really wonderful thoughts about the intimacy of craft and about making whole something that has been shattered, finding that shard, rebuilding the experience, just for the sake of making it art. I've often thought that that's one of the simple things that is really lost in all the discussion about art now. What separates artists and art from other enterprises in a mass-produced culture is that they are lucky enough to make unique things. What that means is often forgotten. It is not about a hierarchy, about putting the artist on a pedestal; it's about being able to collaborate with the viewer in some way on a one to one basis. It's about respect for the receivers' singularity and creativity as

Detail of Mesh Warp technique

Closet Painting (Pepto-Bismol), 1992

Fantastic Prayers (with Constance DeJong and Stephen Vitiello),
2000
CD-Rom

they put the shards together.

That said, I've taken a strange approach sometimes, in that I'll use assistants to draw things on an intimate scale and then rework what they do. In a way, I'm kind of breaking that sense of trust, the belief that these works are anatomically connected to me, which is the way people automatically react when they see a drawing. [Laughs] Those particular works from the late 1990s into, say, 2003, were really more intellectually than physically connected to me. They were related to my timeline project, which can be seen on my website and in a few books. It's a loose alternative history of art from the point of view of virtual image production. So the drawings were a way of processing links within disparities, making connections across time and various scientific fields. It was a perfect situation to involve many hands in the same frame. When I first exhibited a group of them, all my assistants showed up at the opening. It was quite funny. They were standing around in the gallery saying, "Oh, yeah, I worked on this one, I did that one," and so forth. It really upset certain people working at the gallery, they asked me to have them stop saying things like that during the opening. [They laugh]

LC – Oh, that's a great story.

TO – Suddenly I thought, "What have I done? I've cheated people in some way." Then I realized how ridiculous the situation was. In the past, painters always used assistants. But, of course, they tried to get their assistants to paint in a way that resembled their own style, whereas I wanted my assistants to paint in any way they wanted. They would make a move, then I would … it was almost like a chess game. At one point, I had a couple of color-blind guys working for me, fantastic guys …

LC – Deliberately?

TO – No, it was the luck of the draw: I didn't find out for a long time that they were color-blind. But that was the fun of it: it wasn't about controlling the situation. One thing that I always liked about drawing was that kind of loss of control. On the wall a drawing is so contained; no matter how far out of control it gets, how far you break it up, as with Rauschenberg or

the Surrealists, it's still somehow contained. So, in a way, you can't lose. [Laughs]

LC – Did having your assistants contribute to these compositions have a political as well as conceptual aspect to it?

TO – It's hard to say. They were always directed, but to be honest, I've gone back and forth on the question. At one point, it sort of became more work to finish the works. I would get whatever the assistant had done, then I would often think: now I have to fix it. Parts of it are perfect, amazing, nothing I would ever do myself, but it's not exactly the way I want it. Or, it's broken, and now it needs to be fixed. There is something political in this broken relationship. The editing process, the re-cutting, reworking, and the building backed up, and eventually began to take up to two years to complete. It was fun for a couple of years, but then it became too much work. And also, I felt a little guilty about the question of identity because people thought that because the piece looked so personal it was my hand. The overall project was conceptual—I've done lots of work on identity shifting, and multiple personalities—but, in the end, there was something disturbing about it to me. How easily people project identity disturbed me, how much it is valued seemed to point to a shared feeling of cultural disenfranchisement. People are very primitive in the way that they look at work—even fairly sophisticated people. That's been proven time and time again. If a writer writes about a certain thing, then people will immediately transpose it into an autobiographical statement …

LC – That must have happened to you a lot, beginning with those times when you dealt with drug culture. Whether in music, literature, or the visual arts, it's often assumed that if someone's addressing issues like that, they must have had first-hand experiences themselves; it wouldn't be possible otherwise.

TO – Yes. That happened to me very early on, when I was writing science-fiction stories in eighth grade! I remember I wrote this long, elaborate sort of fantasy/sci-fi story that I was very proud of. [Chuckles] I gave it to my teacher, and she immediately brought me down to the headmaster's office. They called my parents. "Your son is on psychedelic drugs." [Laughs] And of course, you know, still to this day, I've never taken psychedelic drugs … But this connects to the way that photography entered my work. Another of my weird habits is to have made, I don't know, may be 15,000 photographs in the past ten years or so, which I've shown to almost nobody. Around the time that I stopped working with painting assistants, I started cutting some of this source material up, collaging my photographs, then over-painting. Working with photographic material rather than using projections or tracings of that material introduced something more impersonal as a starting point, something other than just my own signs of mark making.

LC – Do you take photographs as aide-mémoires? Is photography, for you, like a diary, a way of noting things that are of interest? Did you ever develop a larger purpose for it?

TO – Over that period of time there was a big mixture: some are actually set up photographs, others are video stills, and then there are lots of subsets, such as projects and fantasy books. Our CD-Rom/web project *Fantastic Prayers* is very photographic and yet very much a public artwork. Although most images were shot casually, there is a continuity—some free-flowing research that seems to run through the images. I've always made photographs that I wanted to exhibit. However, early on, in the 1970s and 1980s, it was cost prohibitive: it was just so expensive. For the same reason, I gave up filmmaking. More recently, some of these works, such as the trash pictures, were exhibited, in Europe mostly. But there's very little public continuity in what I've done with them. Eventually, perhaps soon, I'd like to make either a website, or a book, or something similar. That's what you should do when you are 50 … [they laugh] you have to show them all then.

Recently, I've started to develop yet another strange branch: Photoshopped work that is manipulated, and then printed out. A collaboration with David Askevold over the last six months conflated photo, painting, and video. He was so fearless in his ability to move between mediums, layering them to get deep

inside them. I've always been in love with his mind: he lived in a world of images that most people would try to escape, that would make you turn your head away, or block out. He was always lifting the cultural rock, one piece after another. It was such a pleasure to bounce things back and forth between Halifax and New York City with him. He would come up with a system: we would pick a time, say midnight Friday, a sound track, say, *Alien II*, and a duration of activity. Draw with eyes closed for one half hour, then shoot photos, maybe video too. Email each other …

LC – In 1996–1997 you did a show for the Kassel Kunstverein. You called it *My Drawings: 1976 to 1996*. Looking at the catalogue today, there's a lot of work that most people wouldn't think of as drawings. I'm struck by its title; not simply because you suggest that everything in it is drawing, but because you call it "*My* drawings." [Oursler laughs] One way of reading this is to consider it a more personal index of your visual world than would be the case if the show had been given the more neutral and convention title, *Works …*, that is, without the personal pronoun, and without the sense of an intimate entry into you inner world. Then, further complicating these associations, is the fact that the image you put on the cover is a watercolor of a camera! You seem to set up a series of contradictory expectations and then corral a whole range of work into this ambiguous frame. Was this approach a reaction to the fact that other works you were making concurrently were beginning to become much more public? For example, *The Influence Machine*, shown first in New York at Madison Park and then in Soho Square in London. In that period were you again trying to push at both ends of the spectrum simultaneously?

TO – That's a really good read on that catalogue. I had a lot of fun with the title for this particular very homemade book. It was done by the curator of the show, Bernhard Balkenhol, who home-published it. We enjoyed doing it. Since he had one of the first scanners and computers that were able to hold high enough resolution images to print, he came up with the idea that you should be able to see the texture of the paper on which each work was made. That's more or less impossible, but we made a good effort. I really like its kind of homemade feeling; for example, the over-thick pages and the detailing.

You can say that there was a schism that I was playing across in that publication. I definitely wanted to reconcile the two ends of the spectrum. After making the projected installations with figures and eyes for some time, I wanted to introduce different approaches that people were not familiar with. First, there were the older drawing painting props; but gradually I became more and more focused on public works. So there is a private phase to this aspect of my work and then an expanding public drive. Prior to 2000 it was so hard to work with technology in a public place. I did a few window projections and other public projects, but it was difficult. In 2000 I was very lucky to be able to make *The Influence Machine* with the help of the Public Art Fund and Art Angel, and I was able to explore all sorts of new issues, and a new scale, and what it means to be in a public arena. So there began a string of public works and whole new way of making images: images were let loose on the landscape, projected on smoke and water, trees and buildings. Then, of course, there's also the question of iconography, of what works in a specific place: a library, a border town, a desert, a beach, and why?

LC – Given the delays, deferrals, and filtering of subject matter that inevitably goes on with these kinds of projects in the public arena, what for you are their positive aspects?

TO – I believe that there will be an evolution in what a cityscape can be in 50 years or so, due to a number of different elements, not just technology. Right now, a vast portion of the urban space in any city is unused and completely banal, yet it has interesting scale shifts. I've been thinking a lot lately about how to try and understand it, and how to be part of the beginning of an incursion into that space. It's beyond advertising and cinema: we need a new language. These spaces have become so normalized that, mostly, people are bored by them. Yet when something new happens, when there's a really interesting experience, people engage differently. At that moment you have a

chance to become part of the real life of a city, a shared space with all its grim beauty—from the gum on the sidewalk to the skyscraper. That's one of the most exciting things about public art, sometimes even more so when it's permanent. It's also interesting that sometimes things can be switched out …

LC – Updated?

TO – Yeah.

LC – With public interventions, the conditions of a particular site, or its past histories, or its demographics, or any number of other related factors, can become parameters that determine and help shape a work. That's very different from the process of generating something in a vacuum—in the studio—by yourself.

TO – That kind of amplification or connection with various layers of reality and history is really exciting. For example, parts of *The Influence Machine* had to do with the Gothic, and there were also a lot of references to horror movies, spiritualism, and certain kinds of technologies that are used to talk to the dead. The situation in Soho Square was ideal, because it was right near the site of the former lab of John L. Baird, a 19th-century scientist who invented mechanical television. The piece has now become part of the lore of that neighborhood. That will probably diminish as time goes by but, at the moment, people still remember it; it adds to the history of that space.

At the Arts Arcade in Phoenix, I wanted again to work with the lore of the area. It's one of the fastest growing cities in North America but there are all sorts of urban problems due to the urban planning and the demolishing of past histories. I wanted somehow to grapple with that. Certain ideas about culture have fallen apart there. People were really proud of this theater complex, but they later found out that because the area around the theater, which was used only for three hours a night, was mostly empty, it had become a place for drug addicts and the homeless. So, for better or worse, the new idea is to put in stores and a convention center. This project became part of an effort, which included bringing in commerce—bookstores, and coffee shops, and other things—to keep this arts area alive.

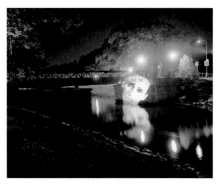

Influence Machine (Swedish Version), 2002
Multimedia installation

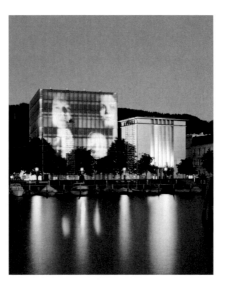

Flucht, 2001
Multimedia installation

Carpet, detail of *Million Colors*, 2006

84

I wanted to look at the history of the West, and work with actors from that area. So we did a casting call to try to reflect, in a very simple way, the people who live there, and make them part of it. Of course, I also used a few of my own actors from here. Some of the incredible history of the Grand Canyon, Suspicion Mountain, copper and gold mining all became part of the language of the piece, and of the way that it was constructed. This became a big research project on Phoenix at large; in that sense it's the most specific piece I've ever done. I worked with the building design, changing areas such as walls and the floor, into moving, speaking images. The text was written in a vernacular rather than a more poetic way: it's rambling, almost conversational, and so it's easy to pick up on. I'm very proud to have that piece. Like the piece in the Seattle Library too, these big public commissions in one way or another become research projects for me.

LC – What other changes do you see in your visual vocabulary that stem from working in the public arena?

TO – Because the imagery in a lot of these bigger pieces ends up being two-dimensional, it's forced me to open up to a space that I rejected back in 1991: the so-called pictorial space. In the public works there are now links to the small-scale pieces, even the works on paper. There's an intimate aspect to the working process, made quietly in the studio, sometimes alone, that can be transferred to a large lonely void of architecture. I remember a quote from Newton, which is something like: you don't see the object—the apple—only the color red reflecting off the apple. With large projections into landscape or cityscape, images fuse into something beyond the sum of the two. That's amazing; it's a part of the language I've got to understand. Working recently in New Zealand, on the Gibbs Farm, that transformation has been essential to the image production.

LC – Do those images get reflected off water …

TO – Off water and mud, with trees and landscape over to the side.

LC – Did those landscape conditions generate a train of thought that produced the imagery?

TO – It's the most intuitive project that I've done in a long time, because it's very much about edges and the way water meets the land in this very, very shallow three-mile tidal basin. I kind of fell in love with the enormous amount of mud and so was reading a lot about the Golem, and also thinking about evolution, about life coming out of the mud and going back into the mud, about creatures coming out of the sea, decomposing, and going back into the sea. I think Darwin stopped near there on his epic voyage.

Then there was the way that, with the large slope running down to the water, everything just broke up into these sorts of Minimalist planes. I made a lot of material that didn't work. And then I had one very interesting kind of optical moment— it's something that happens once in a while, but not very often, when I discover something optically that I've never really seen before. I had made a nest of rubber snakes, which I painted and shot in the studio, moving them three-dimensionally under a really harsh light. I thought it would never add up to anything, but I wanted to try it. When you're working with blinders on, in a situation like that, you have to shoot a lot of material and then just try it: it's part of the process. But I never really believe anything until I see it. This particular image had a lot of detail and dimensionality to it; when projected it popped up into the air in some funny way, and looked almost holographic. I'm not trying to do optical illusions, but it was a very interesting effect that couldn't be denied. In a weird way it goes back to that 1991 moment, when I was thinking about the picture plane. When you're looking at a picture you're very much aware, if you're an artist or someone who knows about pictures, that you're looking into someone's constructed world. When you're looking, for example, at a Hieronymus Bosch space, it's obvious that you have to agree to suspend disbelief, and then you enter in that world. But you're not psychologically part of it. To make a work that is part of your world, physically and psychologically, is something I've been striving for for a long time—suddenly, you're part of the picture. It was really happening with this silly nest of rubber snakes. Anyway, that led

me—this is a long-winded answer—back to analyzing that image and then shooting a whole new body of work that used some of the same optical properties, and that had this same kind of dimensionality, almost like a Calder moving in space. It's funny: a kind of media chiaroscuro. Everything then became three-dimensional, moving in space, with sort of high contrast. For example, there was a great picture of a hand coming out of muck, like in a horror movie. You would really have enjoyed how we made that in the studio. [Laughs] It was so foul: an arm in a big bucket of mud, in a big frame, coming up and going back down. Quite obscene. So this imagery then became very much about life and death on a primordial level. I kept thinking of some of my favorite imagery from what you might call, for lack of a better word, the whole evolutionary "mythology"—even though it is accepted as a science. A scientist named Stanley Miller tried to prove how life began on earth from the primordial soup. What he did was to put all these enzymes and stuff into a tank and then shoot it with electricity. He didn't make life, but certain of the chemicals went to the next level, connecting in some way. I always liked this soup level of connecting and disconnecting: we can somehow understand it but not quite understand it. And so most of the imagery for this piece stayed on that very primitive level—there is no spoken language, just some sounds once in a while—and there are naked forms, pre-humanoid skulls morphing together, so that there's an archeological element to it, too.

LC – Does it run only at night?

TO – It will start at sunset. And then over several hours the images slowly emerge like a long natural dissolve; the atmospheric effects make it different every day. The images are broken up in new ways all the time. The footage is about two-and-a-half hours long. What I'm working on now is the interplay between the four different projections and how they will connect with peripheral vision. When you're looking at the piece now, there's almost always one that's just tickling your peripheral vision. I hope it ends up that way because peripheral space—and the feeling that there's always something there on the margin of what you're seeing—is something I've long been obsessed with, as you know. I think probably that whether people know it or not, they think a lot about that edge: if you're driving or walking, it's the beginning of one space and the end of another; of one outside of you and one inside you. In this piece for New Zealand it becomes a metaphor for the unknown and known. And so if the project works out, you'll always be seeing something that's just appearing—and disappearing—which is perfect, I think, for a night installation in that specific area.

LC – It's a pretty remote location isn't it? I didn't see the site at night but even during the day somehow you sense, physically, that it's quite isolated and that the spaces directly in front of you go on more or less indefinitely. Ultimately, they merge with the ocean: there's no real boundary. This kind of reaction comes, it seems to me, as much from a bodily-based response as from any conceptual knowledge about the unusual character of this natural site.

TO – Absolutely. It's a really unique area. I've spent many days there, and I never felt that there was anyone else around. It's very strange.

LC – I wanted also to ask you more generally about how you generate imagery. Perhaps the best way to begin this is to quote from a statement you made in 2005: "I like to think in terms of the carrier of the image: which images carry cultural resonance at any moment … I guess I'm talking about video. The artist should, in my mind, be the carrier of cultural images." That seems to me to be something you could have said at any moment since your beginnings as an artist in 1976. As you have often stated, for you as an artist, part of the drive to working with video is to be in the midst of what is going on, and to try to shift the ways that images are being made, our visual world is being constructed, and we are being shaped by media technologies, and television especially. You then said something that really surprised me. "But as you go along, there's another problem. As cultural space becomes very clogged with meaningless image production, all of a sudden painting becomes a

contemplative space. For me, it's become more relevant today than maybe it would have been at other times." What struck me was that during the 30 years that separate the mid-1970s from the present, our world has become so saturated by digital and technological imagery as to make it, in effect, a significantly different world for you. For that saturation, or clogging, as you went on to argue, "has had a kind of inversion, making painting or handmade images—and I'd rather say handmade images at the moment—somehow an alternative space that's valuable again."

In the art world at the moment, as, indeed, in the 1970s, there's a tendency to think of painting as the conservative or default position. It's seen as a mainstream medium that suits this very conservative, moneyed era. Your reading, however, places a very different value on painting or, perhaps better, on handmade images. It seems to me that, as in the past, you are again responding closely to the current moment or, at least, your reading of it. The seemingly surprising conclusion you have reached about the options available for working critically has led you not only to revise but even reverse where you once were, and through that to question the very basis of your practice over the past three decades.

TO – [Laughs] I was very surprised to get to that point, because as you know, I had had to sort of kill painting for myself—which I guess a lot of artists had done. As a kid I so idealized it. To get to the point, today, of looking not only at painting, but at abstraction as an interesting and viable spot in a culture that is totally permeated with things that switch on is ... I think it's important to go back and analyze what can be done with certain mediums.

The splatter paintings recently exhibited at Lehmann Maupin in New York were a reaction to that history. Each was a blowup of a trace of a drip, or drop, or drool—some kind of liquid spill. Color is such a personal thing—"I look great in blue!"—yet color carries a slippery cultural history of absurd codification. Depending on which subculture you read, red is for valentines, white for purity or semen, purple for mourning. In these panels I wanted to play across the projected light of TV and the reflected color fields, suggesting body fluids, blood splatter patterns, and a history of painted space. They all speak texts very quietly. I think a painting should whisper if it has to say anything. In any one of these works there are pools of different mediums, perspectives, and conflicting languages. This is an attempt to reconcile two worlds that don't coexist.

It's taken me a long time to realize that one of the problems with video and film is that they are oversaturated with information and that, maybe, all that information doesn't have to be there. I've been thinking a lot recently about this situation. It's like a dump, an information dump site, with a culture of degradation around it, hinted at in the extremely violent movies made by the French filmmaker Catherine Breillat. That then turns into the toxic American garbage, like *Hostel* ... And then there's also the sort of Donald Trump era in television, where people watch people get fired or humiliated or detoxed on TV. It seems as if, out of sheer boredom, people want to be tortured by their own culture. [Laughs]

LC – That's a really persuasive way of putting it.

TO – Right now, I can imagine that contemplative space is going to really be important again. It's more interesting to me to see whether abstraction can become a really sophisticated space than to try to take stuff from pop culture and re-cut it ... I guess it also has to do with the fact I no longer believe that I can learn anything at all from pop culture. [Laughs] I'm not saying that arrogantly. One of the things that I used to enjoy doing was kind of fencing with pop culture: "Well, what about this? Why did this occur? How does this reflect some historical event or ... ?" Maybe I've gotten to another Year Zero, another rehash moment like 1991—I turned cable off two, almost three, years ago so I don't even really know what the shows are. Does that answer your question?

LC – Yes, it does. It leads me to wonder about another statement you made which, at least until recently, seems also to have held true for the past 30 years, in which you have been working: "I like to keep the viewer in the vernacular." At the risk of

turning that statement into a sound bite, it seems to me good shorthand for saying quite a number of things that have been fundamental to your practice. "Fencing with pop culture" is also a phrase which nicely sums up a lot. But as this discussion has developed, I've begun to realize that these may no longer be positions you want to maintain, that there may be other places you would rather be exploring.

TO – I think at a certain point you have to just make it, rather than reflect it or work in it. That's what I want to do now: to make things that aren't necessarily reflections of other things. Work with the same basic human drives that pop culture exploits, in new ways.

LC – That are not reactive in a direct way?

TO – Yeah. Not reactive at all. Because I don't think that there's anything to react to at this point. Of course, probably tomorrow I'll see another Michel Gondry movie or something else and say, "Oh, yeah. He's got it." But this is also probably part of turning 50. I can't look at politics now and say, "Oh, well, you know, that's the old men doing it." I have to say, "That's us doing it. That's me and my generation doing it." And so there's a certain feeling that I have to do what I believe, and that is to make things and to make them with people for people, and not translate them through some kind of pop cultural loop. It's going to be a very interesting way to work in the future. I think the phase we're now in with a lot of communicative technologies argues that Hollywood worked too well; television worked perfectly. But it's obvious to me that they are destructive, they're not working at all: their whole strategies have to be rethought, and redone because they haven't been explored on even the most rudimentary level. The internet has a lot of possibilities that have never been touched, that were either ignored or went out of fashion, and are now forming Webkinz or MySpace, which are interesting to watch. Now there are interactive possibilities, ways in which we can connect in meaningful ways. The thinking is not medium specific—low tech, hi tech, who cares?—we have everything we need to make new work: the question is how can connections become more alive.

LC – Maybe this next question is part of this same point. You once said: "Today, the simulacra is as real as the rest." But now you seem to be saying that you want to make works that acknowledge a difference between what's real and what's mediatized, that is, "real," within inverted commas, like reality television.

TO – There's definitely been a shift in my thinking, and I've changed my point of view completely on that issue. The simulacra have brought some interesting elements. Yet they are overshadowed by the fact that we're more detached than ever. Facilitation of the disconnect, while fascinating in theory, is sad when kids are learning to shoot with the Nintendo Wii. (Although there are some exceptions like the great TV show *Deadwood*.) Basically we're facing a kind of a scorched-earth situation with popular culture. I've not lost faith in technology's ability to create spaces in which we can manipulate consciousness and interact with people. I believe that will never go away, it will just get better; one day, you'll just plug in and your money will get drained away along with other things. The question is always how we go about using it. It goes back to an argument that's almost Marxian. Though there's no way to measure it, the entertainment complex is the place where people become the most disenfranchised. You can measure when somebody can't eat, or when they have a disease, but you can't measure where somebody's dreams are destroyed. That's where I'm interested in drawing lines. I don't know whether I am actually doing it … Just recognizing the problem is one thing: it's good to call out the problem when you see it. When you look at the history of TV, which has now become just a stand-in for lots of new mimetic technologies, there's no doubt in my mind that in some way it should have been regulated as a drug. Though there are very few ways of measuring it and/or dealing with it, we're almost now at that point. As I've said a million times, by the time my generation had graduated from high school, they'd watched TV more than they had done anything else except sleep. When you have these kinds of statistics, it becomes a medical thing. It's no longer just a hobby. The

beneficiaries are advertising agencies and manufacturers of certain goods. It's a very cheap trade for people's lives, for their time and energy. You can say, "Well, people had a choice." But I don't know [laughs] if they really had a choice, or if they still have a choice. Just as we don't allow certain things in the drinking water, so this too needs to be regulated … It's a responsibility. I hope that culture makers can do something now that will be really important.

LC – I agree. The impact of these electronic technologies has expanded so much in the past decade that this does feel like the moment when we've got to grapple with it, on a personal level at least. Whether you begin by turning off cable or even, occasionally, the cell phone, or by not allowing email and SMSs to serve as continuous unregulated prompts, it's important to try to take this invasion of our personal spaces in hand rather than just be at the mercy of it.

TO – Yeah. And it feels good to be in the art world. I feel that the decision I made to become an artist was the right one. I've seen so many things fall to the wayside: it's the one area that I still feel optimistic about—it's an area where a person can break a few things, fix a few things. Of course, there are certain things happening at the moment that aren't very positive. But I'm not going to get into that.

III

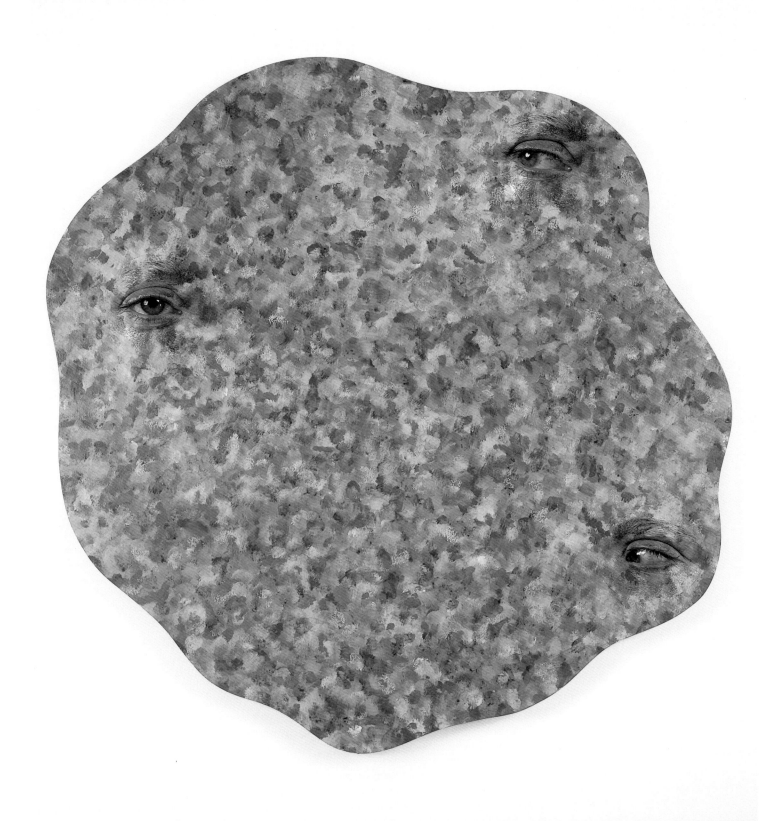

Polymorph-Green, 2004
Acrylic and collage on panel

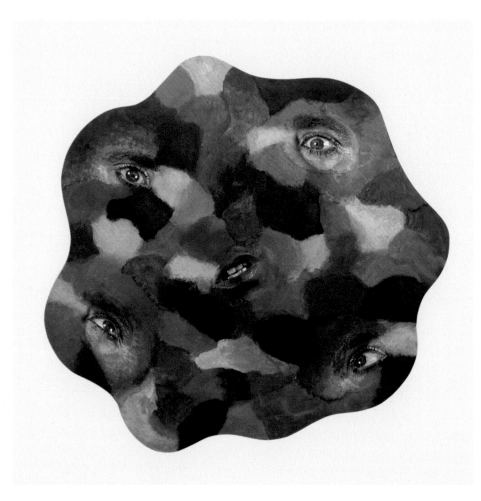

Ether, 2006
Aluminum, acrylic, glitter, LCD screen, DVD player

Polymorph-Polychrome, 2004
Acrylic and collage on paper

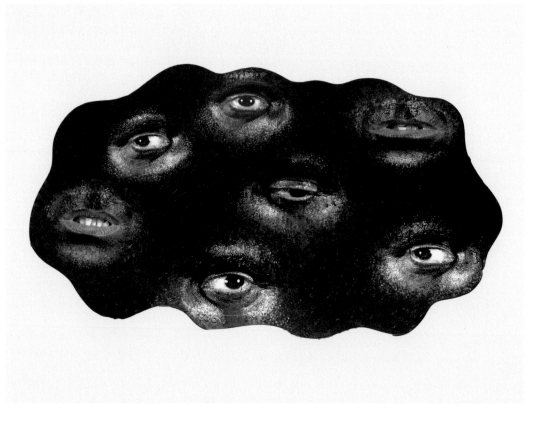

Eclipse, 2004
Acrylic and collage on paper

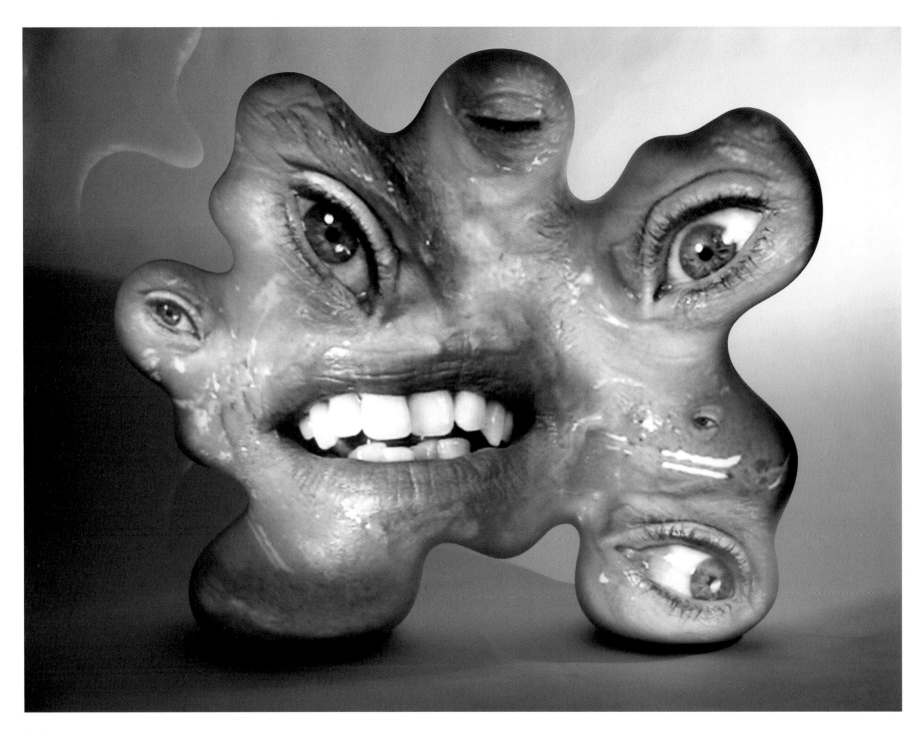

Purplite, 2005
Aqua-Resin, video

Digo, 2004
LCD screen, DVD and DVD player, aluminum, and acrylic

Splotch, 2004
LCD screen, DVD and DVD player, aluminum, and acrylic

Daub, 2004
LCD screen, DVD and DVD player, aluminum, and acrylic

Ruby, 2004
LCD screen, DVD and DVD player, aluminum, and acrylic

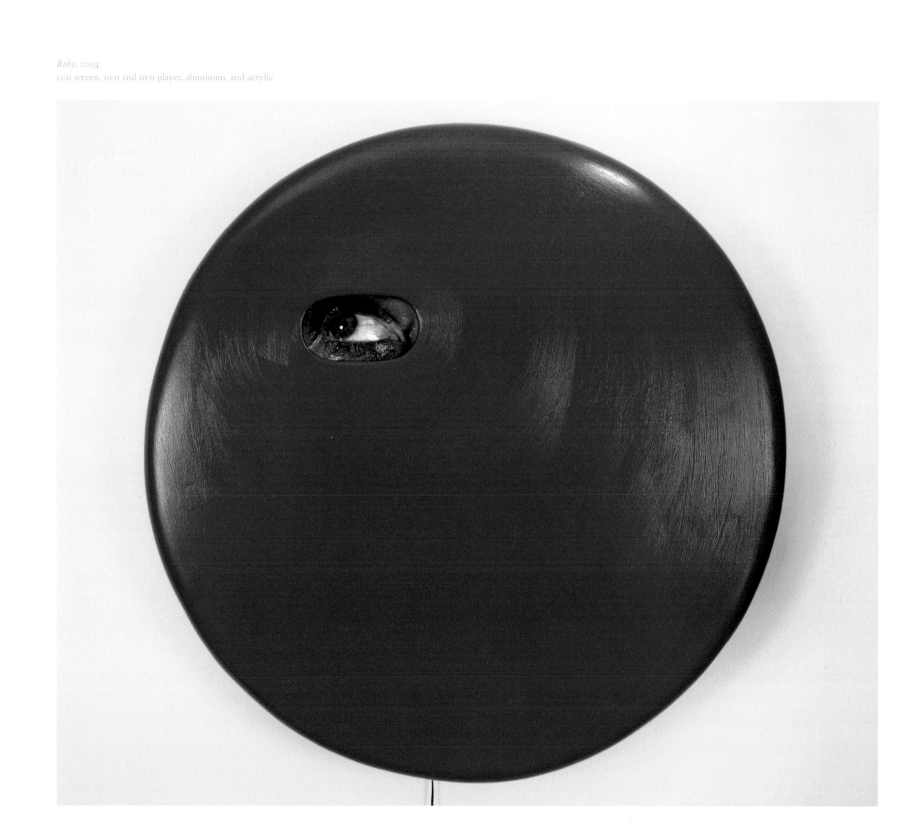

Cowel, 2006
Collage and mixed media on paper

Balls, 2006
Collage and mixed media on paper

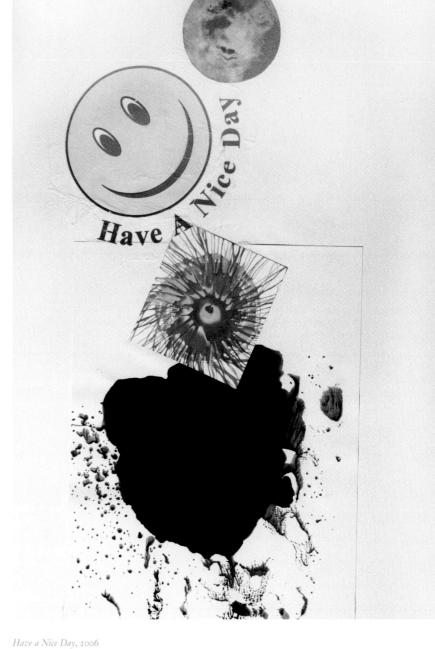

Spaced, 2007
Aqua-Resin

Have a Nice Day, 2006
Collage and mixed media on paper

98

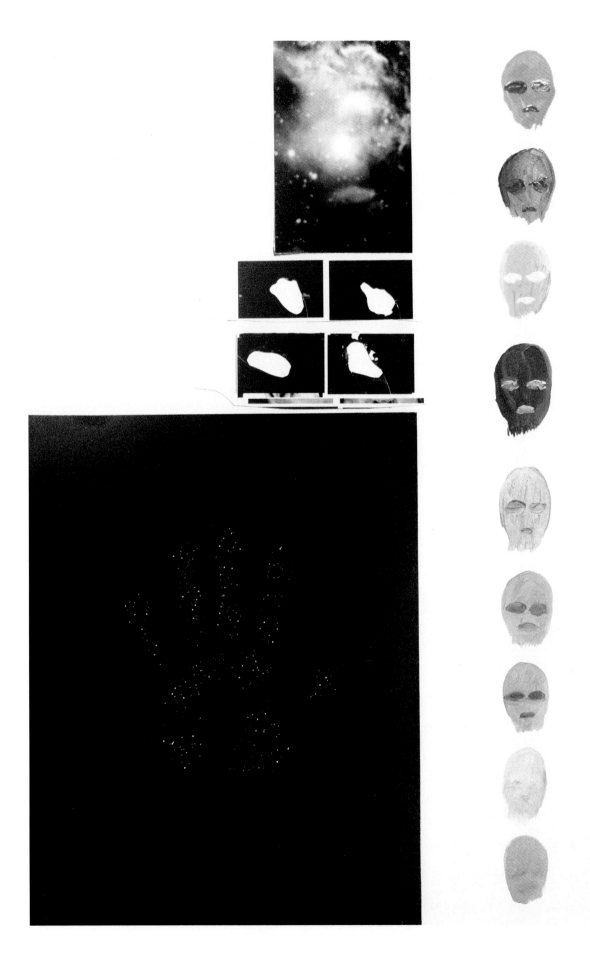

Diamond Ascension, 2006
Collage and mixed media on paper

Moon?, 2007
Acrylic and collage on paper

Smoke Snake, 2006
Carbon on wood panel, video monitor, DVD player

Smoke, 2005
Collage and carbon on paper

Diamond Dust, 2003
Acrylic and glitter with collage on paper

Dust, 2006
Aqua-Resin and video projection

Red "Love Hurts" Laboratory, 2007
Aluminum, acrylic, LCD screen, DVD player

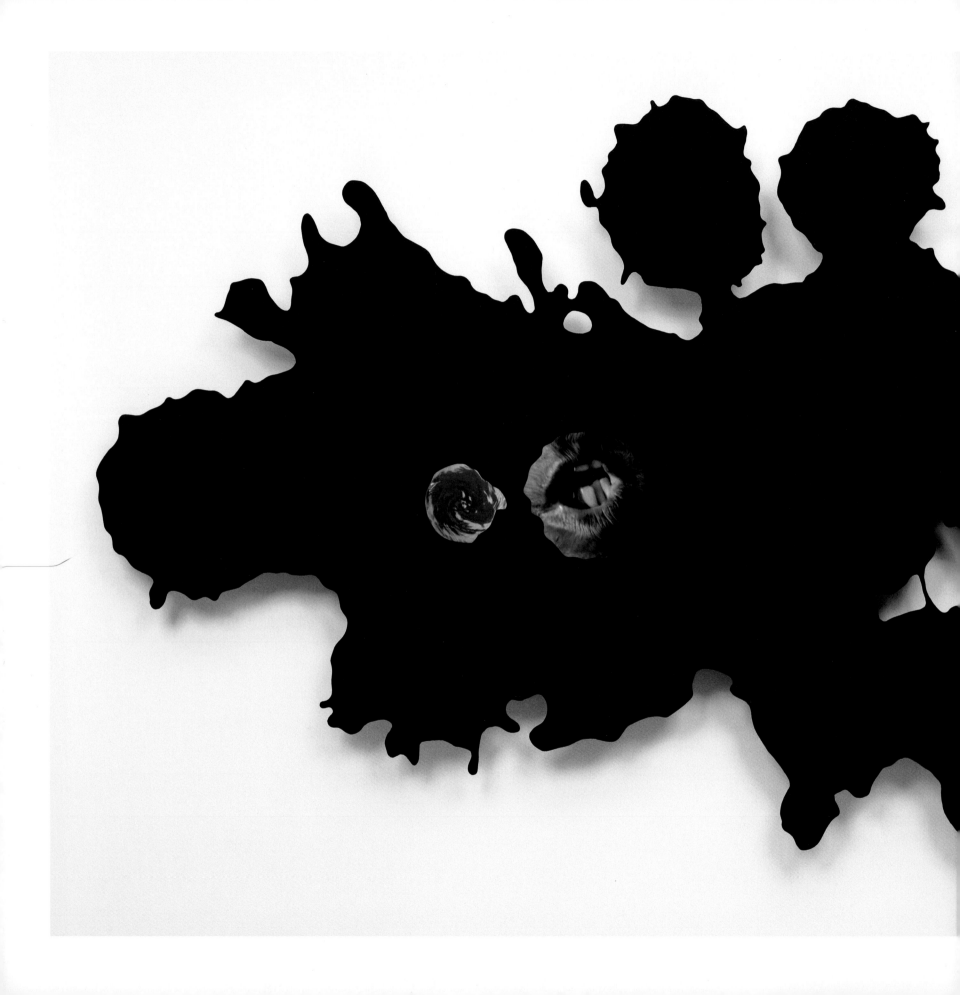

Blackisblackerthanblack, 2007
Aluminum, acrylic, LCD screen, DVD player

107

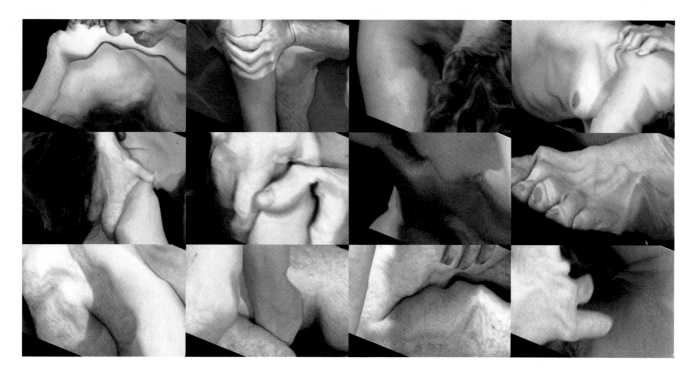

Installation view
Lehmann Maupin Gallery, New York, 2007

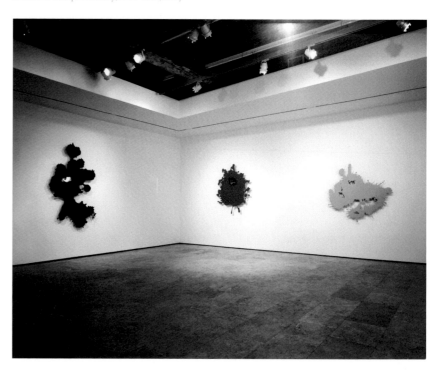

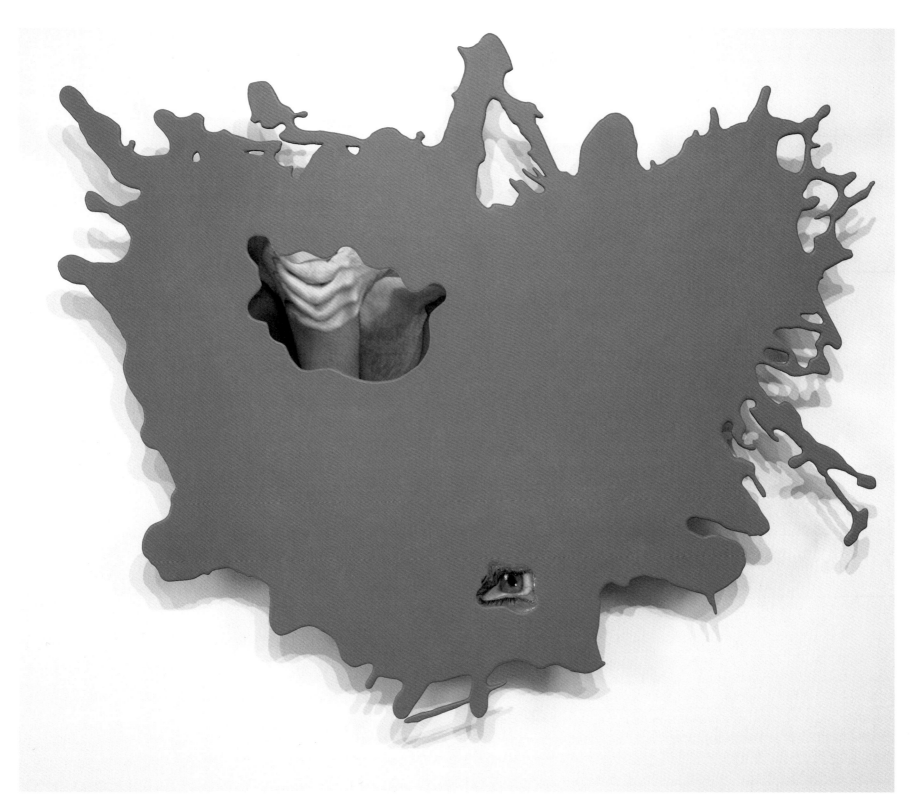

Purple Ideation Exposure, 2007
Aluminum, acrylic, LCD screen, DVD player

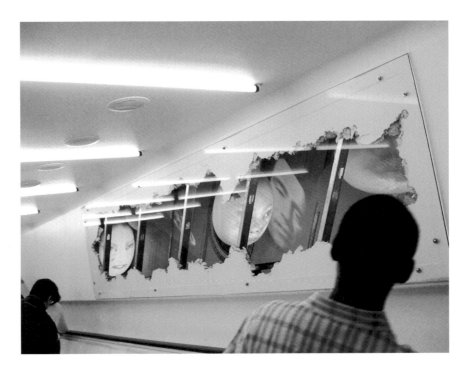

Braincast, 2004
Video installation

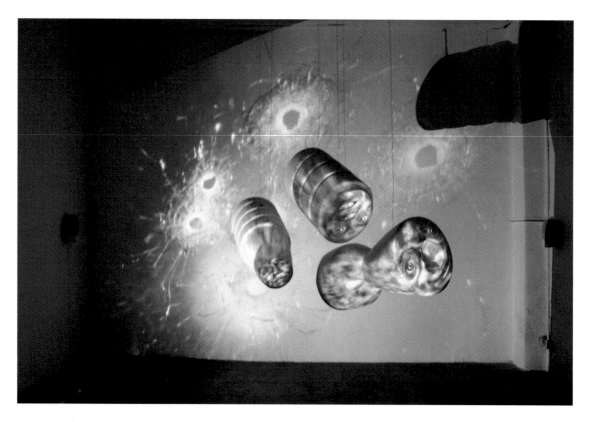

wadcutter-semiwadcutter-I'm-OK-slug, 2007
Aqua-Resin, video

Epistemological Nine, 2007
Inkjet print

Untitled Project for Land and Beach, 2008
Video projections

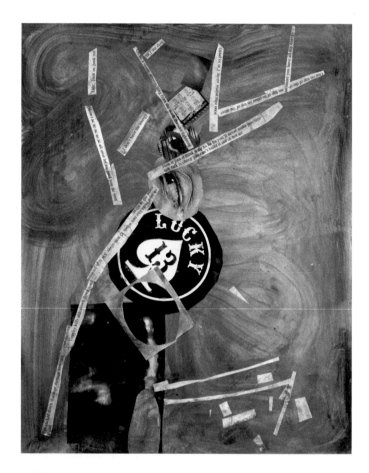

Sad Genealogy, 2008
Mixed media on paper

Untitled Project for Land and Beach, 2008
Video projections

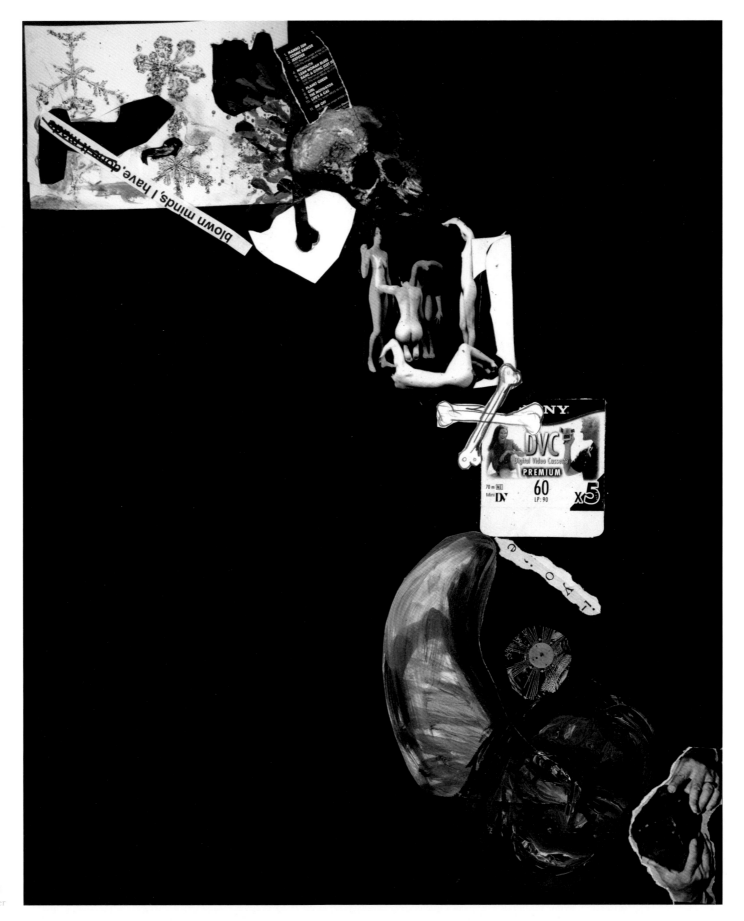

Mostly Negative, 2008
Mixed media on paper

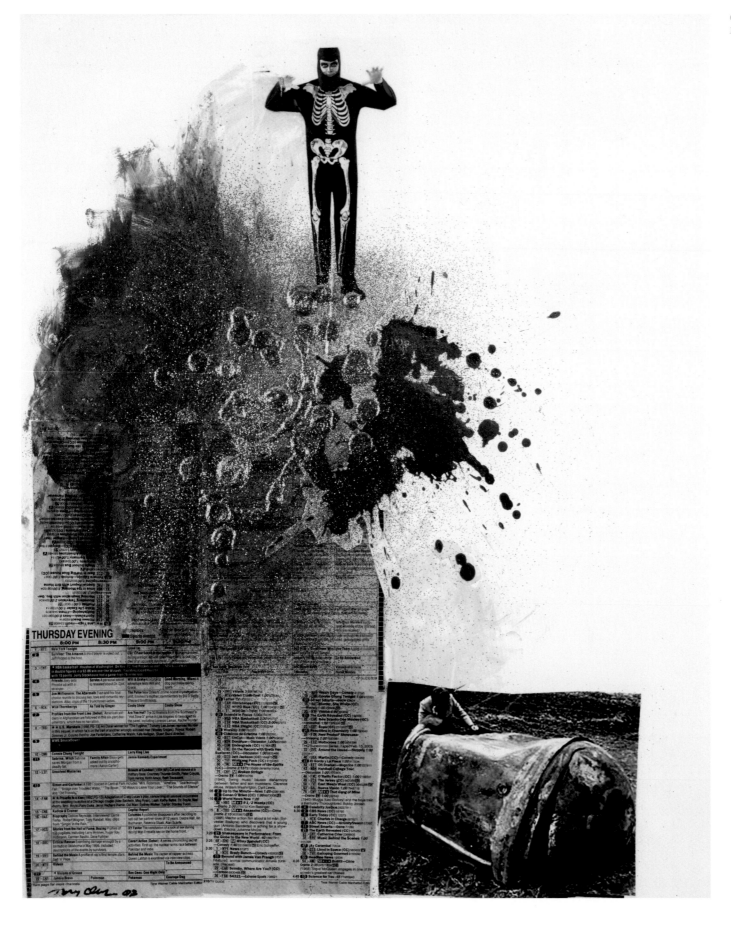

Mask/No Mask, 2008
Mixed media on paper

Scared to Death, 2008
Mixed media on paper

Random Configuration, 2008
Mixed media on paper

Optical Timeline
Tony Oursler

Iris is thought to be derived from the Greek word for speaker or messenger.

Chinese philosopher Mo Ti, in the first description of the camera obscura, refers to the **pinhole** as a "collection place" and "locked treasure room."

Plato's *Cave* depicts the dilemma of the uneducated in a graphic tableau of light and shadow. The shackled masses are kept in shadow, unable to move their heads. All they can see is the wall of the cave in front of them. As a result of being locked into physical sense perception, they are doomed to view only shadows of truth on the wall of the cave. In Plato's metaphor, an unseen fire behind the shackled illuminates a marionette or puppet show taking place above and behind their heads; the puppets' movements represent the interactions of true contemplation, visible to the masses only as indecipherable shadows projected on the cold stone before them.

Homer equates the rainbow/Iris with a **serpent**, a sentiment shared in African mythology, in which the colors materialize as a giant consuming snake attacking the unsuspecting. In the tribal myths of South America we find the rainbow personified in evil figures, and in Eastern Europe the colored light sometimes sucks up water and children.

The prophet **Zoroaster** of Persia describes a character similar to the Christian Devil. He teaches that Ahura Mazda, the god of light, is in battle with the evil Angra Mainyu. A dualist, Zoroaster believes the world is divided between dark and light.

Red

Seth, the Egyptian god most associated with evil, is depicted in many guises: a black pig; a tall, double-headed figure with a snout; and a serpent. Sometimes he is black, a positive color for the Egyptians, symbolic of the deep tones of fertile river deposits; at other times he is red, a negative color reflected by the parched sands that encroach upon the crops. Jeffrey Burton Russell suggests that "it is possible that the redness of Seth helped make red the second most common color, after black, of the Christian Devil."

Egyptian God Seth

The Devil's Arc

A person who crosses or passes directly below will change sex.

First reference to the **persistence of vision**: "This [perception of motion] is to be explained in the following way: that when the first image passes off and the second is afterward produced in another position, the former is seen to have changed its gesture." (Titus Lucretius Carus [98–55 BC])

Symyaz leads the **fallen angels**. According to Enoch, they came to earth of their own free will at Mount Hermon, descending like stars. This description gives rise to the name Lucifer, "giver of light."

"And now there is no longer any difficulty in understanding the **images in mirrors** and in all smooth and bright surfaces. The fires from within and from without communicate about the smooth surface, and from one image which is variously refracted. All which phenomena necessarily arise by reason of the fire or the light about the eye combining with the fire or ray of light about the smooth bright surfaces. Or if the mirror be turned vertically, the face appears upside down and the upper part of the rays are driven downwards, and the lower upwards." (Plato [427–347 BC], *Timaeus*, trans. by B. Jowett, The *Dialogues of Plato* [Oxford, 1875])

Aristotle writes *De Meteorologica*. His treatise devotes a substantial amount of space to a penetrating discussion on the causes of the rainbow, luminous halos, northern lights. This section may in fact be taken as the first truly systematic theory of the rainbow that has come down to us.

During an eclipse Aristotle notices many images of a crescent sun on the ground below a tree. He later discovers that whatever the shape of the aperture, jagged or smooth, the images projected are the same. The riddle is known as **Aristotle's Problem**.

Euclid publishes *Optics*, in which he isolates the concept of a beam of light, and suggests the eye sends out visual rays to the object that the viewer wishes to see.

Archimedes (c. 287–212 BC) is said to have used a large magnifying lens or burning-glass, which focused the sun's rays, to set fire to Roman ships off Syracuse.

"I have seen **Satan** fall like lightning from heaven." (Luke 10:18–20)

Balinese Shadow Puppet

Green

In the Book of Revelations it is stated: "There is a need for shrewdness here: if anyone is clever enough he may interpret the number of the beast: it is the number of a man, the number is 666." One theory of the number's puzzling origin has anti-Roman groups giving letters numerical significance so that coded messages could be passed among themselves. By obscure calculation the number 666 has the letter value of Nero, who ruled 54–68 AD. Nero is known to have enjoyed peering through a rudimentary lens crafted of the gemstone emerald, which has the property of enlargement. This is one of the first records of the use of a lens.

Ibn al-Haytham (aka **Alhazen**), a 10th-century Arabian scholar, publishes *Optics*, which is the basis of Europe's knowledge on the subject until the 16th century. In it he describes the camera obscura. He also expands on the optical understanding

of the Greeks, explaining that light spreads out in all directions from an object. In addition he describes the linearity of light through the use of three candles and one pinhole, proving that we see objects by viewing light reflected from them.

1000
Shen Kua (1031–1095), a Chinese astronomer, mathematician, and poet, expresses the first moral equivalent of the inherent qualities of the camera obscura. He makes an analogy between the camera obscura's image inversion and the nature of man's vision, which can be so polluted as to see right as wrong.

Christians link the **colors of the rainbow** to the seven sacraments.

The Comic Devil appears in popular medieval dramas. His role is slapstic—screaming oaths, making obscene gestures, and executing pratfalls. Like Hell, the character was an inversion of norms of the day.

1200
Robert Grosseteste (c. 1175–1253) translates the works of Alhazen into Latin.

Alhazen's idea of the formaton of the halo c. 1000 BC

Alhazen, who was no fool, wrote his *Treatise on Aspects*: "the wise naturalist who would learn about the rainbow must consult this book and must also possess notions of geometry to understand the demonstrations in this treatise. He will then be able to find the causes and the potency of glasses which possess marvelous qualities: the smallest things, the most minute lettering, tiny grains of sand, are seen so big and thick that they can be exactly distinguished and even counted from afar, which seems incredible to one who has not seen them or does not know the causes thereof.

"Others burn and consume things placed before them if the rays of the sun which strike them are cunningly made to converge … Others cause different images to appear straight, oblique or reversed. So that mirrors according to how they are arranged, can show two objects instead of three, eight instead of four." (Jean de Meun, *Roman de la Rose*)

"**Vision** is of three kinds: direct in those who are perfect, refracted in those who are imperfect, and reflected in evildoers and those who ignore Gods commandments." (Roger Bacon [1214–1292])

French astronomer **Guillaume de Saint-Cloud** suggests in an almanac of

1290
1290 that viewers of an eclipse use a hole in their roof and a board as a projection screen to avoid blindness from staring directly at the sun.

It should be noted that a colorless lunar rainbow is widely considered to be an ill **omen**.

In the 13th century, **Arnaud de Villeneuve**, showman and magician, utilized the camera obscura to stage presentations somewhere between shadow play and cinema: players performed warlike or murderous episodes outside in the bright sunlight, while inside the audience was shocked and delighted by sound effects linked to the dramatic gestures of the projected images. The fact that the audience would stay inside and watch such a mediated event when they could have gone outside and viewed the event directly points to a victory of the virtual image over reality. The disembodiment of the moving image and its removal from the recognizable physical laws that bind the body of the viewer, imbue the image with a magical quality at once distant and intimate.

Albrecht Dürer (1471–1528) illustrated two drawing aids: one involving a grid through which to view images, and another using a ground glass pane to trace images from life.

Buddhists associate the colors of the rainbow with the seven regions of the earth and the seven planets.

1452
First book printed with movable metal type. Johannes Gutenberg printed a bible with movable type in Mainz. He perfected interchangeable type that could be cast in large quantities and

invented a new type of press. September 30, 1452, the first book was published, Johannes Gutenberg's Bible.

Formula for a Homunculus
"Place human semen in a glass vial and nourish with blood for 40 days and 40 nights, keeping it at the temperature of a horses belly: and from it will be born a genius, a nymph, or a giant." (Philippus Aureolus Theophrastus Bombastus von Hohenheim [1493–1541])

1558
Giovanni Battista della Porta publishes details of construction and use of the **camera obscura** in the widely distributed and popular *Magiae naturalis*: "First of all you must close the windows in the room; you will make a round hole the size of one's little finger and opposite you will stretch pieces of white sheets or white cloths or paper; and the result will be that all things which outside are illuminated by the sun you will see inside, you will see those walking in the streets with their heads downwards, as if at the antipodes, and the things on the right will appear on the left and all things over and the further they are from the hole the larger they will appear. I will not conceal at last a thing that is full of wonder and mirth, because I am faln upon this discourse, that by night an image may seem to hang in the chamber. In a tempestuous night anything may be represented hanging in the middle of the chamber, that will terrify beholders. Fit the image before the hole that you desire to make seem hanging in the air in another chamber, that is dark; let there be many torches lighted around about. In the middle of the dark chamber place a white sheet, or some solid thing that may receive the image sent in; for the spectators will not see the sheet, they will see the image

hanging in the middle of the air, very clear, not without fear or terror, especially if the artificer be ingenious … you may see hunting, battles of enemies and other delusions, and animals that are really so, or made by art of wood or some other matter. You must frame the little children in them, as we used to bring them in when comedies are acted; and you must counterfeit stags, boars, rhinoceros …"

Later he discovers that by adding a lens to the enlarged hole, images can be sharpened.

Giovanni Battista della Porta, 1558

1585 **Giulio Cesare Aranzi** focuses sunlight through a flask of water and projects it into the nasal cavity. He is the first person known to use a light source for an endoscopic procedure.

1604 The astronomer **Johannes Kepler** writes *Ad Vitellionem paralipomena*, in which light and the physiology of the eye are explored in depth. He coins the term camera obscura, which had been known variously as *conclave obscurum*, *cubiculum tenebricosum*, and *camera clausa*. By using this device he is able to measure the diameters of the sun and moon. He also demonstrates how the focal distance of a lens can be reduced by interposing a negative concave lens;

this may be the first description of a telephoto lens. As imperial mathematician, Kepler used a portable tent camera obscura to survey Upper Austria.

Anonymous engraving, The Soul of Man, *1629*

1610 **Achilles Langenbucher**, a watchmaker, devises musical instruments that play themselves.

"For since God has given each of us a light to distinguish truth from falsehood, I should not have thought myself obliged to rest content with the opinions of others for a single moment if I had not intended in due course to examine them using my judgment; and I could not have avoided having scruples about following these opinions, if I had not hoped to take every opportunity to discover better ones, in case there were any." (**René Descartes**, *Discourse on the Method of Rightly Conducting One's Reason and Seeking the Truth in the Sciences*, first published anonymously in 1637)

Giovanni da Fontana, 1620

"I will suppose therefore that not God, who is supremely good and the source of truth, but rather some malicious demon of the utmost power and cunning, has employed all his energies in order to deceive me" (**René Descartes** [1596–1650], *Meditations on First Philosophy*, 1641)

"All Knowledge is light and all proceeds from the First, Infinite Light Who is God." (Athanasius Kircher [1601–1680])

1646 Athanasius Kircher, a German professor of philosophy, mathematics, and Oriental languages at a Jesuit college in Rome, publishes *Ars magna lucis et umbrae*. It includes the earliest known illustrations of **magic lantern** slides and the first descriptions of lantern shows and other devices such as dioptrics, lenses of pantoscopes, and telescopes, in "which little known powers of light and shadow are put to diverse uses." Two lenses can be put together to create a microscope, "which will amplify a fly into a camel."

Kircher also describes a portable camera obscura with two apertures and

an inner cube. The outer box has a hole on one side facing another hole on the opposite side. Inside is another box or frame covered with translucent paper. The draughtsman within is able to see an image on two sides of the little paper-walled room.

Kircher describes persistence of vision, likening the change of color in an after-image to the glow of a phosphorous stone when placed in darkness after exposure to light.

1647 **Johannes Hevelius**, an astronomer, designs a lathe that can produce large-scale telescope lenses.

1666 **Sir Isaac Newton** studies the phenomena of colors, laying the groundwork for the modern physical theory of color. To begin, he creates a camera obscura with a triangular glass prism at its "entrance," which he ground himself, focusing and refracting the sun's rays through the dark room onto the opposite wall. There it is "a very pleasing divertissement [diversion] to view the vivid colors" of the spectrum. These experiments culminate in his letter of February 6, 1672, to the

Newton's investigation of light refraction through a camera obscura and prism

Royal Society of London, which outlines his discovery of the properties of light rays. Newton also notes that the relative color or perceived color of objects is determined by the quality of the light striking the object. For example, an apple tends to reflect red in a full spectrum of light. As Newton points out, it is useless to think of an apple as red, for **"any body may be made to appear any color"** by controlling the reflected light. Newton is also the first person in history to unlock the riddle of the rainbow when he applies his understanding of refraction to the water droplets in the air.

1675 **Jean Picard**, the French astronomer, is walking home late one night from the Paris Observatory, swinging his barometer by his side. To his great surprise, the glass tube emanates a faint glow; the more he shakes it the more it glows: "the glow of life."

1706 **Francis Hauksbee**, an English student of Sir Isaac Newton, invents a machine that produces "the glow of life" at will. Hauksbee's Influence Machine consists of a hand-cranked device that spins a glass vacuum globe, half full of air. The mysterious luminosity can be produced by touching the surface of the glass as it spins; also produced is a crackling sound that reminds the inventor of lightning.

Hauksbee's Influencing Machine

Etienne de Silhouette (1709–1767), French controller general of finances, cuts out profiles of his contemporaries in black paper.

1717 Richard Bradley describes the **kaleidoscope** in a work on garden design.

1720 Louis Bertrand Castel invents the **clavecin oculaire** or optical harpsichord. The keys trigger not only sound but also a corresponding color produced by transparent colored gels.

1725–27 **James Graham** establishes the Temple of Health in London. He invites childless couples to indulge in sexual intercourse in his celestial or magnetico-electro bed within a therapeutic electric field created by Hauksbee's Influence Machine.

1738 Jacques de Vaucanson amazes the world by exhibiting in Paris a number of **automata**, including a life-size Flute Player and the celebrated Duck, which is reported to flutter its wings, swim in water, eat, drink, and, finally, pass the food as amorphous matter.

1745 **Pieter van Musschenbroek** invents the Leyden jar, a storage container for a continuous flow of relatively large amounts of electricity, considered the first battery. Previously, experimental scientists were forced to rely on unpredictable, spontaneous electrical phenomena such as static electricity or attracting lightning to a metal pole, for example.

1746 Abbé Nollet conducts electricity from a Leyden jar through the bodies of Carthusian monks holding iron wire. The monks form a circle 5,400 feet in circumference. The simultaneously

shocked contortions that the monks display, when the circuit is closed, proves that electricity is felt throughout the entire circuit and that electricity travels very quickly.

1749 **Horace Walpole**, a young British socialite, begins to convert his home, Strawberry Hill, into "a little Gothic castle." The interior is to become a repository of everything antique; when he can't find an object he desires, he employs artisans to build a replica for him. His random collection of oddities from throughout the ages, such as a Roman tomb with the bones of a child within, are aesthetically arranged. The towers and stained glass are not in themselves designed to evoke fear; the setting is meant to stimulate visitors to feel a bygone era when our predecessors believed dwellings to be haunted. This influential building may be seen as the origin of a resurgence of Gothic and the camp/pop cultural interpretation of the past that is so prevalent today in theme parks, architecture, and media.

1763 **Edward Gaspard Robertson**, showman-scientist-occultist, is born in Liège. In his memoirs Robertson writes of his fascination with "Father Kircher" and of the early motivations that he shared: "Who has not believed in the Devil and werewolves in his early years? I admit frankly that I believed in the Devil, in raising the dead, in enchantments … Since the Devil refused to communicate to me the science of creating prodigies, I would apply myself to creating Devils, and I would have only to wave my wand, to create all the infernal cortege to be seen in the light. My habitation became true Pandemonium."

By the 1790s he shifts his exploration from the occult to the science of

Illustration of Robertson's Phantasmagoria from his Mémoires

optics and, finally, to a new theatrical form. In 1794 Robertson founds the Phantasmagoria, an influential sound and light show in Paris, which makes use of his own graphic designs and innovations in the magic lantern projection system. He combines performers, props, and sound effects produced by the Musical Glass (and a robotic trumpet player) and projects moving images on clouds of smoke and layers of gauze curtains. In the area of slide projection, he introduces the idea of painting images on an opaque black background rather than on clear glass—so the images seem to float free in the air. His theater, a "vast abandoned chapel" dressed up with elaborate "Gothic" decor, is the first permanent auditorium (he performs the Fantasmagoria for six years) for projected audio-visual shows. So convincing are his illusions that "gentlemen drew their swords, ladies fainted." He insists that his aim is not to deceive the public but to arm them against irrational superstition. His themes are

culled from popular lore, historic and religious: *The Apparition of the Bleeding Nun*, *Chinese Tamtam*, *The Death of Lord Littleton*, and *Preparation for the Sabbath*.

Robertson's redesign of Archimedes' legendary Burning Glass for the French Government

1796 Jean-Jacques Rousseau coins the word **melodrama** to describe a drama in which words and music, instead of proceeding together, are heard in succession, and in which spoken phrases are to some degree announced and prepared for by musical phrases.

1773 Jean Pierre and Henri Louis Droz produce **The Scrivener**, a robotic writing figure who dips his pen into an inkwell and writes a limited number of words.

1784 **Friedrich Anton Mesmer**, an Austrian physician, is legally forbidden to practice in France. His treatments involve groups of patients conducting the current known as animal magnetism through chambers, huge vats, or metaphorical

"batteries" of mysterious solutions. The treatments, accompanied by shouts, hysterical laughter, and music, end in mattress-lined rooms for the patients' decompressions.

1800 Humphry Davy, English electro-chemist, is the first to observe the light produced by the discharge of electric current between two carbon electrodes. The **arc light** is produced.

1801 Frenchman, J.M. Jacquard invents the **Jacquard Loom**.

1802 Thomas Holcroft's play, *A Tale of Mystery: A Melodrama*, is innovative in its use of music and calls for intensifying dramatic moments by the sonic expression of "discontent and alarm," "chattering contention," and "pain and disorder." Over the next 40 years, stage music evolves into a modular system of repeatable phrases known as *melos*, each identified with a different emotion.

1806 **Bozzini** employs an aluminum tube to visualize the genito-urinary tract. The tube, illuminated by candle light, has fitted mirrors to reflect images. Bozzini's invention, "a magic lantern in the human body," is ridiculed at the time.

Magic Lantern

1809 Humphry Davy invents the first electric light—the first **arc lamp**.

1814 Joseph Nicéphore Niépce achieves his first **photographic images** with a camera obscura.

1817 What is the normal state of a room? One could say that a dark room is a more natural and normative state than a lighted room. As with the cave before it, the room is enclosed and inherently cut off from natural light. Windows can be employed to let light and air into a room, but daylight is limited by the cycles of the sun. At night artificial light is needed to illuminate the chamber. The open fire gave way to more controlled forms of light: oil lamps, candles, and finally, in cities, systematically supplied gas.

Swedish Baron Jöns Jakob Berzelius isolates the element **selenium**.

1824 Englishman, Joseph Aspdin patents Portland **Cement**, the modern building material.

Peter Mark Roget of Thesaurus fame demonstrates the **persistence of vision** with his Thaumatrope.

1825 William Sturgeon invents the **electro-magnet**.

1831 Joseph Henrys' single-wire **telegraph** is introduced.

1832 **Charles Wheatstone** invents a non-photographic "stereoscopic viewing device."

Electric currents can travel rapidly along wires of infinite length. **Samuel Morse** interrupts the current and shapes it into combinations of dots and dashes to represent the 26 letters of the alphabet, the ten numerals, and all punctuation

marks. The Morse Code foreshadows the on/off nature of binary code—a series of zeros and ones—used in modern computers.

1833–1838 **Michael Faraday** investigates electrical discharges of gases using vacuum tubes in which a current is passed from a negative electrode to a positive electrode, producing a glow on the inner surface of the opposite end of the tube.

1834 William George Horner patents an image-animation device, the Daedelum or "Wheel of the Devil." Later, around 1864, French inventor Pierre Desvignes refines the device for the home market under the name **zoetrope**, "wheel of life."

Simon Ritter von Stampfer invents the **stroboscope**, a device using variable-speed, extremely bright flashing light to create the optical effect of capturing motion in a series of frozen images.

1841 Frederick de Moleyn first uses a vacuum for **electric light bulbs**.

1842 Alexander Bain elaborates on Edmond Becquerel's research into the electro-mechanical effects of light and proposes the idea of **scanning** an image so that it can be divided into small, transmittable parts. According to his theory, electrified metal letters could be scanned by a pendulum and duplicated on chemical paper at the other end of the telegraph wire by a synchronized pendulum.

1843 **Rogues' Gallery**: the first index of photographed criminals is organized by the Brussels police.

Talbot makes the first instantaneous photographs using electric spark illumination.

Telecommunications

1844 — Samuel Morse sends the first message by electric **telegraph** from the Supreme Court in Washington D.C. to Baltimore. Miss Elsworth, the daughter of the commisioner of patents, composes the message: "What hath God wrought."

1858 — Heinrich Geissler, a German glass-blower and maker of scientific instruments, creates the **Geissler tube**. A vacuum is created in a glass container sealed with electrodes at either end. Electrons moving through the tube are visible as patterns of light, varying according to the shape of the tube or the type of gas introduced into the vacuum. This invention will lead to the discovery in 1890 of cathode rays, a basic principle of video technology.

1859 — Establishing an important principle for the future of electronics, the German mathematician and physicist Julius Plücker discovers that cathode rays (electrons) are deflected by a **magnetic field**.

Alexandre Edmond Becquerel, a member of the noted family of French physicists, uses a Geissler discharge tube filled with fluorescent material to create the first fluorescent lamp.

1860 — Oliver Wendell Holmes invents a popular **stereoscope** viewer.

1860–1880 — Photographic lightning is believed to be a flash of lightning that creates the image of a person on an ordinary windowpane or mirror. In American folklore the legend encompasses the possibility that sick, dying, or dead people leave images of themselves on glass surfaces in the building of their confinement. The subjects are criminals, victims, and sometimes Jesus Christ. Folklorist Barbara Allen suggests that popular misunderstanding of the new technology such as the photographic plate spawned such lore, and with the introduction of flexible film, the glass plate legends decline.

1864 — **Lewis Morris Rutherford** pioneers astrophotography.

Pigeons are used to carry microphotographed messages across enemy lines.

1865 — **Gregor Mendel**, the "father of genetics" and Austrian monk, publishes his findings on the laws of inheritance based on experiments, begun in 1857, with pea plants. His studies are ignored until 1900, well after his death in 1884.

1868 — **Sincere Acting**: "This woman's nature was one in which all … experience immediately passed into drama, and she acted her own emotions … It would not be true to say that she felt less because of this double consciousness." (George Eliot, describing Princess Halm-Eberstien in *Daniel Deronda* [1868])

1869 — Edward Everett Hale's "The Brick Moon" is published in *Atlantic Monthly*. Hale describes an artificial **moon**, or satellite, that he thought could be used as a military post.

1870 — Dr Vernois of the Society of Legal Medicine of Paris publishes his theory of the **optigramme**. He believes that at the point of death, the retina freezes the last frame of ones life and retains the image until decomposition of the body. The forensic implications of the theory are explored by surgically removing the retinas of murder victims and examining them under a microscope.

1872 — **Joseph May**, a worker at Telegraph Construction and Maintenance Co., tests transatlantic transmissions using rods made of selenium as resistors. He finds the resistance to be inexplicably variable; his lab desk is near a window, and he notices that when a ray of sunlight strikes the test rods, current flows freely through it, while in the dark the electricity crawls. The company's head electrician, Willoughby Smith, later takes credit for the discovery. Recognizing the implications of the phenomenon, he follows up with extensive experimentation and soon proposes "visual telegraphy." He states at the time, "selenium's sensibility to light is extraordinary … a mere Lucifer match being sufficient to effect its conductive powers."

1876 — Alexander Graham Bell, trained in speech therapy for deaf people, patents the **telephone**. "The telephone operates by translating vocal sounds into a fluctuating electric current, which passes through a wire and is converted back into vocal sounds by a receiver at the other end of the wire." (Christos J.P. Moschovitis, Hilary Poole, Tami Schuyler, Theresa M. Senft, *History of the Internet: A Chronology* [1999])

1878 — Eadweard Muybridge publishes *The Horse in Motion*.

Dennis Redmond develops the "electric telescope" to produce moving images.

1879 — General Electric introduces the first Edison carbon filament electric light bulb.

1880 — The first articles written about early models of television are published in *Nature*, *English Mechanic*, and *Scientific American*.

1881 — Roebuck Rudge and Friese Greene use a lantern with a scissors shutter to animate consecutive images of a man removing his own head.

The British inventor Shelford Bidwell transmits silhouettes using both selenium and a scanning system. He dubs the device the "scanning phototelegraph."

Artificial lighting during theatrical performances causes audience discomfort; viewers are subjected to extremes of temperature (the ceiling goes from 60 to 100 degrees) and suffer headaches due to the fact that gaslight consumes large amounts of oxygen, while its exhaust includes ammonia, carbon dioxide, and sulfur. In Berlin the effects of **gaslight** on luxurious public decor and architecture are noted: "The gas flames began their destructive work … blackening the ceilings … most surfaces turned yellow … and the oil paintings almost disappeared or were darkened by smoke."

1884 — Etienne-Jules Marey develops the **chronophotography** device, which looks very much like a machine gun. He successfully exposes a number of photographic images in quick succession, thus capturing exact details of motion that have never before been seen. One of his first motion studies is of a flying bird, which he then presents on an electric zeotrope. Marey, a scientist, is interested in using his devices only for speeding things up or down to study locomotion. He shies away from the replication of real time, stating that the absurdity of such an undertaking "would be attended by all the uncertainties that embarrass the observation of the actual movement."

Etienne-Jules Marey's photographic gun

1886–1889
German scientist **Paul Gottlieb Nipkow** patents an image-scanning machine made up of a spinning disk placed between a scene and a selenium element. Nipkow argues that if the disk is turned fast enough, it can show a moving picture.

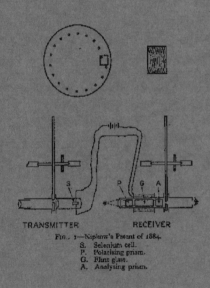

TRANSMITTER RECEIVER
Fig. 1—Nipkow's Patent of 1884.
S. Selenium cell.
P. Polarising prism.
G. Flint glass.
A. Analysing prism.

German physicist Heinrich R. Hertz produces **radio waves**.

1888
On February 27, Muybridge meets Edison and suggests the combination of their respective inventions—the zoopraxiscope and the phonograph.

George Eastman markets the **Kodak**, a roll-film camera capable of taking 100 separate pictures without reloading. Eastman provides developing and printing facilities: "You press the button, we do the rest." Amateur photographers come into being.

Frederick Eugene Ives files a patent for taking **color photographs**.

Dr Roth and Professor Reuss of Vienna use bent glass rods to illuminate body cavities.

1889
A. Pumphery (UK) invents and markets the **cycloidotrope** or Invisible Drawing Master, a machine that will "trace an infinite variety of geometric designs" upon smoked or darkened glass slides for the magic lantern. By turning a hand crank, one produces a rudimentary animation of white or tinted lines on the screen.

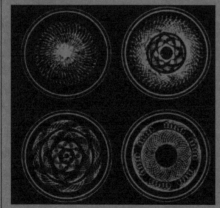

First commercial transparent roll film makes possible the development of the movie camera.

1890
German physicist Karl Ferdinand Braun invents the Braun tube, an adaptation of a Lenard cathode ray tube, which is the forerunner of the **TV picture tube**.

Heinrich R. Hertz develops electromagnetic **radiation**.

The US government undertakes the census of 1890, two thousand clerks are hired to run Herman Hollerith's mechanized tabulating system. This marks the birth of the now-ubiquitous office machine as well as IBM (International Business Machines). Clerks translate each citizen's age, sex, and ethnicity into a pattern of holes punched on a card; Hollerith's electromechanical machine totals the information. Each machine processes one thousand cards an hour. The census takes two and a half years. (Christos J.P. Moschovitis, Hilary Poole, Tami Schuyler, Theresa M. Senft, *History of the Internet: A Chronology* [1999])

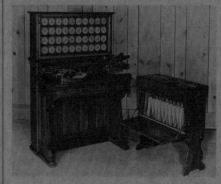

Hollerith's Tabulator and Sorter

1892
Jacques Arsène d'Arsonval studies the psychological effect of electrical current on humans.

1893
Thomas Edison patents the **kinetoscope**.

Red Shift
The systematic increase of the wavelength of all light received from a celestial object is observed in all segments of the spectrum to shift toward the higher or red end. This is mostly caused by the Doppler effect on the light of the heavenly body as it travels across vast distances of space.

1895
German physicist Wilhelm Conrad Röntgen discovers **X-rays**; slide makers publish long lists from which to choose interesting and macabre examples ranging from coins in a purse to a bullet lodged in a cranium.

George **Méliès** works as a magician/artist at the Robert-Houdin Theater, which regularly combines lantern shows with performances. On April 4, Méliès shows his first film at the theater, along with Edison's kinetoscope films. Also on the bill are boxing kangaroos, serpentine dancers, seascapes, and white silhouettes on black. He founds the first production company, Star Film, which produces 500 films from 1896 to 1912; fewer than 90 survive. Méliès himself plays the Devil in a number of his own films.

On December 28, in front of the Grand Café in Paris, 30 people watch Auguste and Louis Lumière's *Workers Leaving the Lumière Factory*, as the **Lumières** and Edison demonstrate motion picture cameras and projectors.

Lumière Bros.' first manufactured camera

Mélìes as Satan in The Devil And the Statue, *1902*

1896 Italian physicist Guglielmo Marconi invents a system that allows electric waves to relay Morse Code messages.

German Karl Braun invents the cathode-ray tube.

1900 Max Planck introduces the **quantum theory** in physics.

The first mass-marketed camera, the **Brownie**, is released.

1901 Marconi transmits the first **transatlantic** radio signals—the Morse Code signal for SSSSSS.

1902 Otto von Bronk applies for a German patent on **color television**.

1904 Alfred Korn announces **facsimile** telegraphy.

Alfred Maul, an engineer in Dresden, Germany, sends cameras up in rockets.

1907 English inventor **A.A. Campbell-Swinton** and Russian **Boris Rosing** independently suggest using a cathode-ray tube, instead of the Nipkow disc, to reproduce a television picture on a phosphorous-coated screen. The vacuum tube can both amplify electrical signals and act as a switch for routing electrical pulses through a circuit.

1909 "Phantom Rides," films shot from the front of a boat or train, are distributed. Audiences find the simulated motion intriguing and disorienting.

General Electric introduces the Mazda trademark on Edison light bulbs.

1910 Portable (home) high-frequency **electrotherapy** devices are marketed as health aids. These machines send electrical charges through shaped vacuum tubes filled with various gases to send rays into the body. The tubes are held against the skin or eyes or inserted into the nose, mouth, ear, urethra, vagina, or anus. The violet or ultraviolet ray machines are said to cure everything from pain to cancer. The following is a chart of the possible discharges at various vacuums:

1. Normal red vacuum level
2. Slightly higher violet vacuum level
3. Higher yet white vacuum level (note phosphorescence of glass)
4. Highest Crookes vacuum level (note yellow-green phosphores cence of glass from cathode-ray/ X-ray formed inside tube).

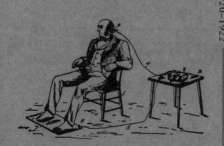

Electric Extraction of Poisons

1912 Alfred Maul sends a gyroscope-stabilized camera up to two thousand feet. It returns to earth in a parachute.

1913—1915 Gene maps show chromosomes containing linear arranged genes.

What is that sound? Where is that voice coming from? I don't see anybody, yet I clearly hear a voice speaking to me. It is not inside my head. Could it be God or the Devil? No, it is from inside the machine. Ray Kellogg invents the electric moving-coil speaker.

A case of paranoia. Freud analyzes a young woman who is convinced that someone is following, watching, and photographing her. She has detected this surveillance by hearing clicking or knocking sounds that she believes to be the shutter of the camera taking her picture. Freud analyzes the aural hallucinations as originating within the woman's body, and the clicks to be an aural displacement of the throb of her excited clitoris.

1920 **Albert Abrams**, MD, invents a so-called "radionics" system, which uses the crystals of dried blood from a patient to perform as do the crystal detectors of homemade radio and transmit the patients disease.

1920-1922 Ernst Belin works on and introduces **wireless** transmission of photographs.

At fourteen, Philo T. Farnsworth devises electronic **television scanning**. He tells his friends and teachers about it.

First radio network established by AT&T.

American Charles F. Jenkins engineers a mechanical **television** system based on the Nipkow disk.

John Baird sells his soap business, and moves for health reasons from London to the seaside town of Hastings. There

Baird's Nipkow disk, 1922

he shares a flat with his boyhood friend Guy "Mephy" Robertson, nicknamed for his seeming resemblance to Mephistopheles. In this pastoral setting he decides to try to construct a television. The world's first working television was to "grow to fill my bedroom," which he shared with Mephy: "It became a nightmare cobweb of … junk … At last to my great joy I was able to show the shadow of a little cross transmitted over a few feet." Some of the objects used in the invention: cardboard cross, wires, an old hat box, electric batteries, bicycle lamp lenses, a used tea chest, sealing wax, glue, scissors, lamp bulbs, darning needles, a neon lamp, a Nipkow disk, wireless valves, transformers, selenium cells, and electric motors.

1923 Vladimir Zworykin applies for patents for a **television** picture tube.

1925 On October 30, John Baird transmits his first decipherable moving picture: the head of a dummy.

Dinshah P. Ghadiali is jailed for fraud. He is the founder of a nationwide cult in the US that uses his **Spectrochrome**. His machine, based on a theatrical spotlight, generates and focuses colored light to heal people.

John Baird transmitting, 1925

1926 The USA Radio Act declares public ownership of the airwaves.

Purple
Television is conceived with the advent of photoconductivity and the further refinement of the photoelectric cell. The notion of translating or coding the bright and dark areas of images into a corresponding electrical signal and decoding it back into an image at another location is within reach. Baird, unable to build a photocell that works, is aware that the light sensitivity of the human eye resides in the purple fluid found in the retina called visual purple. He decides to experiment with a real human eye. He goes to Charing Cross Ophthalmic Hospital, is taken for a doctor, receives a fresh eye wrapped in a cotton wool, and returns to his lab in the attic at 22 Frith Street, London. There he dissects the eye with a razor, and unable to put it to use, throws it into a local canal.

1927 On September 7, Farnsworth transmits a straight line, the **first image** ever to be transmitted electronically.

General Electric invents the modern **flashbulb**.

Bell Laboratories performs the first mechanical television transmission in the United States.

Warner Bros., faced with bankruptcy, launches sound film (*The Jazz Singer*).

Radio changes from a two-way communication device to a one-way broadcasting device thanks to commercial interests and their representatives in Congress (Radio Act of 1927).

1928 **Panchromatic** film, which registers all light in the visible spectrum is developed. So is infrared film, which is designed to pick up light that is below red on the spectrum, light that is invisible to the unaided human eye, or even an object in no light, just from the heat the object gives off.

1929 On July 17, Dr Robert Goddard, the American rocketry pioneer, launches the first liquid-fueled **rocket** equipped with a camera.

1933 The first patent for the **Drive-In Theater** (United States Patent # 1,909,537) was issued on May 16, 1933. With an investment of $30,000, Richard Hollingshead opened the first drive-in at a location on Crescent Boulevard, Camden, New Jersey.

1934 **Philo T. Farnsworth** publicly demonstrates electronic television.

The electron microscope is developed in Germany.

1936 **Alan Turing** conceives of a punch card system that can do more than add. The theoretical Turing Machine mechanically scans a virtually endless tape that is punched with coded instructions or digital sequences of zeros and ones.

Philo T. Farnsworth

Turing proves that you can translate all sorts of complex problems into these strings of simple elemental operations.

Bell Telephone Co. (BTL) starts exploring a technique to transform voice signals into digital data, which can then be reconstructed (or synthesized) into an intelligible voice, the **"vocoder"** (short for voice coder). The research is developed by the National Security Agency (NSA).

1937 Chester Carlson invents **xerography**.

1941–1943 FCC authorizes commercial TV in the United States.

J. Gilbert Wright, a researcher at General Electric, is contacted by Thomas Edison's spirit by way of the medium, Mary Olson. The spirit directs Wright and his partner, Gardner, to the blueprints of the machine for contacting the dead that Edison had supposedly been working on at the time of his death. They faithfully construct this device, which consists of a sound box, a microphone, and a loud speaker, under Edison's supervision.

BTL works under the direction of A.B. Clar (who later led the R&D activities of NSA from 1954) to develop a vocoder that emphasizes the preservation of voice quality via a twelve-channel system. This system becomes known as SIGSALY (Secure Digital Voice Communications). BTL invents the fundamentals and transmission of digital, encrypted voice.

The British Foreign Service's Department of Communications constructs **Colossus**, the first fully operational, fully electronic computing device. A powerful cryptoanalysis tool, Colossus operates in binary, reads incoming data from punched tape, and is controlled by hundreds of vacuum tubes that serve as switches. (Christos J.P. Moschovitis, Hilary Poole, Tami Schuyler, Theresa M. Senft, *History of the Internet: A Chronology* [1999])

1945 Arthur C. Clark proposes a geosynchronous **satellite**.

Engineer John Bardeen, with Walter Brittain and William Shockley, attempts to apply semiconductors to electronics. **Semiconductors**, such as silicon, are materials whose conductivity can be deliberately or predictably altered using electricity.

Vannevar Bush describes **Memex**, the first personal computer (in theory), in the *Atlantic Monthly*. The article later reappears in the widely distributed *Life* magazine. Memex is a desk that contains large amounts of information compressed onto microfilm. The user sits at the desk, swiftly accessing information by operating a board of levers and buttons. The desired information appears on translucent screens propped on the desktop. (Christos J.P. Moschovitis, Hilary Poole, Tami Schuyler, Theresa M. Senft, *History of the Internet: A Chronology* [1999])

ENIAC (Electronic Numerical Integrator and Computer) is unveiled in a basement room at the University of Pennsylvania. It covers 650 square feet and contains 300 neon lights, 10,000 vacuum tubes; 220 fans are required. The massive computer can carry out 5,000 operations per second.

John von Neumann publishes a report on EDVAC (Electronic Discrete Variable Automatic Computer). Von Neumann outlines "stored-program-computing" for the first time: the computer's storage device houses the program's instructions along with the imput data. Thus, more memory is available. Von Neumann also coins the now universal computing terms: memory, input and output, organs, and gates. (Christos J.P. Moschovitis, Hilary Poole, Tami Schuyler, Theresa M. Senft, *History of the Internet: A Chronolgy* [1999]).

Introduction of the atomic bomb at Hiroshima, Japan.

1946 CBS demonstrates **color TV** to journalists and the FCC in the Tappan Zee Inn at Nyack-on-the-Hudson, New York.

Whiteside Parsons, a devotee of Aleister Crowley's magic and a brilliant scientist at the Jet Propulsion Laboratory in Pasadena, CA, attempts to create a homunculus, literally an artificially conceived person occupied by a preterhuman spirit. Among the oldest of alchemical legends, Crowley's Moonchild suggests that a homunculus could be created when both parents were Crowleyan initiates who performed the required sex magic rituals. The embryo created by their congress would act as a "butterfly net" to capture the appropriate spirit. The resultant child would be

human in the commonplace biological sense but for all pragmatic occult purposes would function as a homunculus. After the appropriate chants, intonations, and gestures, Parsons and Marjorie Cameron commence sex magic congress in the presence of L. Ron Hubbard, who describes the activity taking place on the astral plane Tragically, on June 20, 1952, Parsons is blown apart by an explosion in his garage. Bloody body parts are visible in the rubble. Today Parsons is credited with aiding in the creation of solid rocket fuel, which is commonly used in space exploration. A crater on the moon is named after him, honoring his achievements in this field. (Bill Landis, *Anger: The Unauthorized Biography of Kenneth Anger* [New York: Harper Collins, 1995])

1947 Dennis Gabor describes the principles of **holography**.

Walter Brattain and John Bardeen of Bell Telephone Laboratories devise the **transistor**, an electronic switching mechanism and amplifier (to replace vacuum tubes). "The first transistor, the point-contact transistor, stands ten centimeters high—contains a semiconducting crystal of germanium, which serves as the amplifier, connected to 3 wire probes. A current entering one probe is amplified when it passes through the crystal and out through another probe." (Christos J.P. Moschovitis, Hilary Poole, Tami Schuyler, Theresa M. Senft, *History of the Internet: A Chronology* [1999])

1948 Ampex Corporation markets first commercial **video tape recorder**.

A device called the **Cathode-Ray Tube**

Amusement Device was patented in the United States by Thomas T. Goldsmith Jr. and Estle Ray Mann. It described using eight vacuum tubes to simulate a missile firing at a target and contains knobs to adjust the curve and speed of the missile.

1950 First US **cable television system** appears.

1952 **Alan Turing** is convicted for indecency (participating in homosexual activity) and is sentenced to take large doses of estrogen.

OXO, a graphical version of tic-tac-toe, was created by A.S. Douglas, at the University of Cambridge, in order to demonstrate his thesis on human-computer interaction. It was developed on the EDSAC computer, which uses a cathode ray tube displaying memory contents as a visual display. The player competes against the computer (which incorporates basic Artificial Intelligence) using a rotary dial.

1953 **DNA structure** is resolved to be a double helix by James D. Watson and Francis Crick

1954 **Alan Turing** eats half of an apple dipped in cyanide and dies.

Clarence Kelly Johnson, designer for Lockheed Aircraft, designs the Utility-2 (U-2) Jet and privately dubs it "The Angel." The Hyon Corporation develops the "B-camera" for the U-2. Its revolutionary mylar film and lens (conceived by Dr James Baker of Harvard) can photogragh the entire U. S. in just twelve flights and can resolve a 2 × 2 ft. object from a 13-mile altitude.

Lawrence Curtiss, an undergraduate physics student, invents a process by which fine glass fibers can be coherently bundled in order to convey an entire image: the **Fiberscope**.

1956 Emmett Norman Leith develops the data processing system that allows holography to work. **Holography** is the recording and reconstruction of a wavefront. The reconstructed hologram wavefront is identical to that which issued from the object.

1957 **Sputnik**, the first satellite, is launched by the Soviet Union [Union of Soviet Socialist Republics]. The satellite, a metallic object the size of a beach ball, rotates around the earth for three months and then falls—it burns up when it hits the atmosphere.

1958 Color is synthesized from a monochrome television set in the first "flicker color" broadcast.

Kukla, Fran and Ollie, a children's show, begins color television broadcast.

Pope Pius XII declares Saint Clare of Assisi the patron saint of television.

Researchers at Bell Telephone Laboratories invent the **modem**, short for modulator-demodulator. The device converts data from the computer format (digital) to the telephone-line format (analog) and back again. Modems make computer networks possible. (Christos J.P. Moschovitis, Hilary Poole, Tami Schuyler, Theresa M. Senft, *History of the Internet: A Chronology* [1999])

William Higinbothom created a game at Brookhaven National Laboratory in New York using an oscilliscope and analog computer. Tennis for Two was played with two box-shaped controllers, both equipped with a knob for trajectory and a button for hitting the ball.

1959

The Dataphone, the first commercial modem, designed by Bell Labs

Tennis for Two

First television picture from space, 1960

Robert Noyce of Fairchild Semiconductor and Jack Kilby of Texas Instruments simultaneously design the **integrated circuit**, later known as the microchip. The transistor is miniaturized into a tiny pattern etched onto a slice of silicon, becoming the integrated circuit. This development makes it possible to create much smaller versions of electronic devices, eventually including the microprocessor and personal computer.

First ruby **laser** built by Theodore Maiman.

1960

First successful hologram produced.

First manned space flight.

1961

Computer engineer Paul Baran, in the paper "On Distributed Communication Networks," describes what later becomes known as packet switching, in which digital data are sent over a distributed network in small units and reassembled into a whole message at the receiving end. The network is designed to improve the security of strategic weapons communications systems that are vulnerable to nuclear attack. The new systems would function even if some of its subcomponents were destroyed:

1) Instead of a common decentralized network (telephone system), several interconnected main centers are linked like a net, each location connected only to its immediate neighbors; messages have multiple pathways by which to reach their destinations and can always be rerouted.

2) The system chops up the message and sends each piece by a different route.

1961–1962

The American National Standards Institute renders the ASCII character table as the standard character representation system for the computer industry. Computers use the binary system, in which numbers are represented by sequences of ones and zeros, to store, process, and exchange information. Programmers use other characters. A translation process is required. ASCII assigns a particular binary number to each character of the alphabet (A = 1000001).

1963

Early Bird (Intelsat I), the first telecommunications **satellite**, is launched; live video feeds from all over the world begin.

1965

Larry Roberts, a young computer scientist at Lincoln Laboratory in Boston, creates the first long-distance computer connection, a rudimentary telephone link between his computer and one in Santa Monica, California.

Psychologist Tom Marill proposes that ARPA fund a long-distance computer between MIT's Lincoln Laboratory's TX-2 computer and System Development Corporation's Q-32 in California. The link allows the machines to send messages to one another. The device that connects the computers to phone lines works badly, but it works.

Ted Nelson introduces the terms **hypertext** and **hyperlink**, thematic links between documents, to refer to the structure of a theoretical computerized information system called Xanadu that would be organized associatively, not sequentially.

The first **video game** is created by engineers at Sanders Associates, a New

1966

Hampshire-based defense contractor. Ralph Baer conceives the design. He recalls: "I'm ... thinking about what you can do with a TV set other than tuning in channels you don't want." The first toy Baer and Bill Harrison make consists of a lever that players pump furiously to change the color of a box on a television screen from red to blue. The first games are all two-person games in which players control every object on the screen.

NASA launches five Lunar Orbiter satellites. Together they photograph the entire **moon**.

Sony introduces the **Portapak**, the first portable video recording system.

1967

Ralph Baer continues the development, and in 1968 a prototype is completed that can run several different games such as table tennis and target shooting.

Prototype for target shooting game

On July 20, **Neil Armstrong** becomes the first person to walk on the moon. Apollo 11 mission is transmitted and broadcast live from the moon.

1969

Glenn McKay creates psychedelic light shows for rock bands that combine the live manipulation of pigmented liquids and film projection systems.

ARPANET prototype of the **Internet** is initiated.

THE ARPA NETWORK
DEC 1969
4 NODES

A sketch of the original ARPA net structure as outlined by Larry Roberts

Allan McLeod Cormack and Godfrey Newbold Hounsfield bring about the use of computerized axial tomography (**CAT** or CT scanning); detailed anatomic images of the brain become available. They win the 1979 Nobel Prize for Physiology or Medicine for their work. This work leads to development of radioligands, single photon emission computed tomography (SPECT), and positron emission tomography (PET).

1973 Magnavox's **home-video console** Odissey sells for $100 with 20 games including *Tennis*, *Volleyball*, *Shooting Gallery* and *Cat and Mouse*.

Nolan Bushnell created the world's first video-game juggernaut with **Atari** in 1972.

Atari's Pong, a home-console version of the coin-operated video game

Brad Fortner and others develop *Airfight*, an educational flight simulator.

1974 US Air Force Development Test Center, Eglin Air Force Base, Florida, begins developing the weapon system to be popularly known as the **Smart Bomb**. The bomb is guided by a television Electro Optical TV via Mid-course guidance Beacon Data Link during the day, and an Imaging Infrared Seeker via Beacon Data Link during the night. Live images from a camera in the bomb are sent to a remote operator, who uses them to guide the bomb to a target.

1975 It is now estimated that by the time a person reaches 18 years of age, he or she has, on average, attended school for 10,800 hours and watched television for 20,000 hours.

The Atari 2600 (originally the Atari VCS) is the first successful cartridge-based console; it has a library of hundreds of games including such classics as *Space Invaders*, *Adventure* and *Pitfall*.

SMTE (Society of Motion Picture and Television Engineers) recommends the use of the color bar for registration of color on TV.

Apple introduces the home computer; the company logo depicts a rainbow-colored apple with one bite taken out of it.

Apple Computer logo

Sony demonstrates first consumer camcorder.

1980 Scitex, Hell, and Crosfield introduce computer-imaging systems.

1981 **MTV** begins broadcasting.

1983 **Kary Banks Mullis** discovers the polymerase chain reaction enabling the easy amplification of DNA.

1986 On October 4, the Transcommunication Study Circle of Luxembourg (CETL) receives its first video image of its **spirit partners**. Jules and Maggy Harsch-Fischbach record it on a VHS recorder with a Panasonic A-2 video camera. The image of a man, Pierre K, appeared on the TV screen for a duration of 4/50ths of a second. "Using high-tech communication the dead are now transmitting information to our scientists in pictures, text, and voice via television screens, computers, and telephones. Technology allows people without bodies to communicate." (Jules and Maggy Harsch-Fischbach of CETL)

CETL suggests that there is a parallel communications lab in the spirit world: Timestream Space Lab. The facilities are located in the third plane of the astral world on a planet named Marduk. The Spirit-side technicians state: "We have a body like yours. It consists of finer matter and vibration than your dense, coarse physical bodies. There is no sickness here. Missing limbs regenerate. Bodies that are disfigured on Earth become perfect. We live in comfortably furnished houses. We soak up noise, such as hiss between radio stations, and turn it into artificial voices."

1987 The FBI creates Carnivore, a clandestine system for sifting through e-mail on the Internet. Carnivore software runs a packet sifting program, which notes all messages inside the ISP network by origin and destination. Thus the FBI can extract and read messages of interest.

"Hijacking the Net": front cover of Newsweek, *Febuary 2000*

Red-eye reduction is used in cameras.

A **human genetic map** is produced showing the chromosomal locations of markers from more than 30,000 human genes. Alec Jeffreys introduces DNA fingerprinting as method of identification.

Gulf War news coverage is highly controlled by the US government. Video footage from cameras in the tips of the GBU-15 smart bombs, which features views of their rapid decent to their target, is released to the media. Weapon video is either electro-optical (TV camera) or infrared and is generated in the nose of the weapon. The laser guidance system can bring the bomb within four yards of the target.

CU-SeeMe, a live video streaming program for the Internet, is developed at Cornell University. The program allows anyone to broadcast in cyberspace.

An ATM camera records a Ryder truck outside Oklahoma City's federal office building just before the blast that kills 167 people. That image helps police track down bomber Timothy McVeigh.

Jennicam. A 23-year-old exhibitionist launches a Web site featuring real-time video of her mundane daily activities. She develops a large following.

Cookie: a piece of information generated by a Web server about the user's preferences are secretly stored in the user's computer. Cookies are swapped back and forth between the Web servers and the user's computer without the users consent or knowledge. As a result personal information of all sorts can be transmitted to Web servers.

Dildo Cam is a ubiquitous feature of pornographic Web sites. Short videos, usually available by subscription only, allow the viewer literal access, via video, into the vaginas and rectums of porn stars.

Dildo Cam advertised on web-site

Six hundred Japanese children and a few adults are rushed to emergency rooms after watching the television program Pocket Monster (**Pokémon**). The flashing red eyes of the cartoon monster cause some viewers to fall into convulsions. One person in 200 suffers from epilepsy, and of those, 5 percent have photic seizures, which may be provoked by frequencies of 5 to 30 flashes per second. Other triggers may be: TV and computer screens, video games, faulty screens and lights that flicker, sun shining through a row of trees viewed from a passing car, looking out of a train window, sunshine on water, stroboscopic lights, and geometric shapes or patterns.

MUDs (Multi-User Dungeons) Internet gaming expands, Id software's 1996 game "Quake" pioneers play over the Internet in first person shooters: FPS games. MMORPGs (Massively Multiplayer Online Role-playing Games), such as Ultima Online and EverQuest, freed users from the limited number of simultaneous players in other games and brought the MUD concept of persistent worlds to graphical multiplayer games.

Live slow motion. Lene Vestergaard Hau slows down a light pulse from 300 million meters per second to 17 meters per second by passing it through a cloud of laser-tuned sodium atoms chilled to less than 50 nanokelvins. Optical properties of materials can be altered with this process. She states: "It's really opened up a lot of new exciting things that you can start doing."

New York Civil Liberties Union volunteers walk the streets of Manhattan in search of every **video surveillance** camera, public or private, which records people in public spaces. Volunteers produce a comprehensive map of all 2,397 surveillance cameras.

voyeurdorm.com, a "reality based" Web site, goes online. "Six students live in a house with 40 webcams. For $34 a month, you can watch their daily activities: smoking, sleeping, urinating, bathing. The rules: no sex, but masturbation is okay; no drugs, but booze is allowed; absolutely no moving the cameras away from you; no skipping out on the daily chat sessions; no boyfriends after 11 pm; and most importantly, no leaving the house without consent, except for the two nights a week each resident has off." (Mark Boal, "Behind the Cams at Voyeurdom: Surveillance Sorority" [*The Village Voice*, August 4, 1999])

Two variants were adopted for the 1997 IEEE 802.11 standard on wireless communications: 802.11a for the 5.8 GHz band and 802.11b for the 2.4 GHz band. The technology was soon named **Wi-Fi**.

Sikorsky helicopter company constructs a remote controlled, pilotless helicopter drone called the **Cypher**. It looks like a flying saucer and uses commercially available people-tracking software to find human targets in urban riot situations.

Professor Paul Swain invents the **endoscope**, a camera in a pill or capsule 11 mm by 30 mm, it includes a tiny light source and transmitter. It radios images from inside the body to a portable recorder strapped to the patients waist. The pill camera is eventually excreted.

An endoscope, the pill camera

Ensormatics, a leading manufacturer of surveillance cameras that built its $1 billion international business on anti-shoplifting technology, estimates that 62 percent of middle- and high schools will implement some form of **electronic security** by 2002.

Fluorescent Green Jellyfish/Monkey Embryo is created in a lab. Scientist Gerald Schatten of the Oregon Primate Research Center at Oregon Health Sciences University introduces jellyfish genes into the developing embryos of Rhesus monkeys. The gene encodes instructions for a protein that gives the jellyfish a green glow. When fluorescent light is shined on the embryos, "more than a third of embryos fluoresced." Although the genes are not found in the monkeys after birth, scientists say it is just a matter of time before the

procedure will work for primates, including humans. The technique also works with mice. Ryuzo Yanagimachi and his colleagues at the University of Hawaii mix the same jellyfish gene with mouse sperm, inject the sperm into mouse eggs and create embryos. After the birth of the mice, Yanagimachi detects a green glow in the tails of the mice under a fluorescent light.

2001

Rockstar's **Grand Theft Auto III**. An open-ended 3-D crime drama from the third-person perspective, it breaks traditional dependence on linear play.

It is reported that scientists have detected **high-energy neutrinos** for the first time in the Antarctic Muon and Neutrino Detector Array (Amanda).

Guilty Knowledge, a lie-detection test based on technology developed by Daniel Langleben at the University of Pennsylvania, uses MRI machines to compare the brain activity of liars and truth tellers.

The European Commission's Joint Research Centre uses Adaptive Brain Interface, the system they developed to interpret the signals from a plastic cap put on the user's head with attached electrodes that picks electromagnetic signals from the brain. The user, Cathal O'Philbin, a 40-year-old paraplegic, was instructed to think about a rotating cube, moving his left arm (which is paralyzed) and relaxing mentally in between. These three distinct patterns were used to control the cursor on the screen. After several hours Mr O'Philbin trained the system to recognize his mental states and managed to type "Arsenal Football Club" using his brain alone. It is reported that scientists in Chicago have connected a lamprey eel's brain to microprocessors to steer a **robotic device** toward light.

Delft University of Technology in the Netherlands reports the creation of **nanotechnology** transistors built from a single molecule.

The Max Planck Institute for Biochemistry in Germany affix snail neurons to transistor chips and demonstrate communication.

Lucent's Bell Labs reported the development of a tiny new transistor made of a simple cluster of organized molecules.

2003

The revolutionary **T-ray camera**, sees through fog, clothing (notice the concealed gun in this image) and into deep space. The camera detects tera-hertz waves that straddle the border between radio and optical emissions.

Image from the T-Ray camera

A US company launches Mexican sales of **microchips** that can be implanted under a person's skin and used to confirm health history and identity.

Super Black
National Physical Lab in Britain develop NPL Super Black, a nickel-phosphorus compound that absorbs 99.65% of all visible light. Black paint absorbs about 97.5% of visible light.

Super Black

GeneChip
This is the first chip to contain all the 50,000 known human genes and variants. It is a research tool from the Affymetrix company for identifying and isolating each gene.

GeneChip

Infrared Fever Screening System
Invented in response to the SARS scare, this device can scan a person and detect temperature from a distance, producing a color-coded thermograph. Located in public spaces such as airports, hotels, and hospitals it can help prevent the spread of disease.

Grand Theft Auto III, 2001

New light transmitting concrete has the strength of the traditional material and is embedded with an array of glass fibers that conduct light. Inventor **Áron Losonczi** states: "Shadows on the lighter side will appear with sharp outlines on the darker one."

2004

The whole solar system is photographed by the **Voyager**.

The **Hubble Space Telescope** is launched; this eye in the sky has become the most important instrument in the history of astronomy. Hubble Ultra Deep Field or HUDF is the most sensitive space image ever made: 800 exposures taken over the course of 400 orbits around the earth with a total exposure time of 15.8 days. This data was collected over September 3, 2003, and January 16, 2004. This image is the deepest image of the universe ever taken with visible light looking back in time more than 13 billion years.

Scientists say they have created a new form of matter, called a **fermionic condensate**. It is the sixth known form of matter, after gases, solids, liquids, plasma and a Bose-Einstein condensate.

Keyhole Inc. program Earth Viewer produces a geospatial virtual image of the globe. A mapping of the whole surface of the earth is available on the Internet site **Google Earth**.

The FDA approves a clinical trial by Cyberkinetics on implants in humans for a **brain-computer interface**.

2005

HP researchers introduce groundbreaking **nanotechnology** that could replace traditional transistors on computer chips.

2006

Invisible?
Analyses predict that it should be possible to ferry electromagnetic waves around an object to hide it. All that is needed is a properly designed shell of "metamaterial," an assemblage of tiny metallic rods and c-shaped rings.

An ordinary microscope cannot resolve features smaller than about 200 nanometers of visible light used to illuminate an object. For years, physicists and engineers have devised schemes to get around the "diffraction limit." Stimulated emission depletion (**STED**) is used by researchers to assemble an image with a resolution of tens of nanometers.

STED imagery

2007

The **video game industry** has grown to become a $10 billion industry, it now rivals the motion picture industry as the most profitable entertainment industry in the world.

Checkpoint Systems Inc. says it will provide Reno GmbH with **RFID** (radio frequency identification) tags and store tagging systems. Reno GmbH plans to embed wireless chips in shoes sold at hundreds of stores across the continent.

Washington State will implement a voluntary program to implant radio-frequency ID (RFID) chips in driver's licenses to speed border crossings. Border agents will electronically retrieve identification and citizenship information from people as they drive up to crossings between Washington and Canada.

NYC Police Department is creating **Manhattan Security Initiative** a web of surveillance cameras around lower Manhattan.

List of Works Reproduced

1
Polymorph-Green, 2004
Acrylic and collage on panel
45 × 44 ½ inches, 114.3 × 113 cm
Private collection, Belgium

5
The Poetics Project—Why I Love Drums, 1997
Acrylic, glitter, and speaker on wood panel
Music by Mike Kelley
4 feet × 8 feet, 120 × 240 cm

6
Electric Blue, 2002
Sony VPL-CS4 projector, DVD player, antenna,
Plexiglas disc, DVD
Performance by Joe Gibbons
Galerie Hans Mayer, Dusseldorf

7
Camera Remote, 2002
Acrylic on paper
29 × 15 ¾ inches, 73.7 × 40 cm
Lehmann Maupin Gallery, New York

8
Anti, 2002
Acrylic on paper
24 × 19 inches, 61 × 48.3 cm
Lehmann Maupin Gallery, New York

9
Untitled, 2001
Acrylic on paper
24 × 19 inches, 61 × 48.3 cm
Lehmann Maupin Gallery, New York

Mediumud, 2001
Acrylic on paper
24 × 19 inches, 61 × 48.3 cm
Lehmann Maupin Gallery, New York

10
Friends, Friends, Friends, 2002
Acrylic on paper
30 × 22 inches, 76 × 56 cm
Lehmann Maupin Gallery, New York

The Darkest Color Infinitely Amplified, 2000
Video installation
Whitney Museum of American Art, New York

11
Horror Harmonies, 2000
Acrylic on paper
30 × 22 inches, 76 × 56 cm
Lehmann Maupin Gallery, New York

12
(clockwise, starting upper left)

Disk (Deep Blue), 2002
Acrylic on paper
40 × 30 inches, 101.6 × 76 cm
Lehmann Maupin Gallery, New York

Disk (Maxout), 2002
Acrylic on paper
17 × 14 inches, 43.2 × 35.6 cm
Lehmann Maupin Gallery, New York

Disk (Hidden), 2002
Acrylic on paper
17 × 14 inches, 43.2 × 35.6 cm
Private collection, New York

13
DVD (Wrong), 2002
Acrylic on paper
14 × 11 inches, 35.6 × 27.9 cm
Lehmann Maupin Gallery, New York

14
Power Pole, 2002
Acrylic and fabric on paper
30 × 22 inches, 76 × 56 cm
Private collection, New York

Ride, 2002
Video, 20' 3" (loop)

15
Double Blind, 2000
Acrylic on paper
30 × 22 inches, 76 × 56 cm
Lehmann Maupin Gallery, New York

16
Optics, 1999
Mixed media installation with video projection
Variable dimensions
From *Blue Transmission*, 1999, Lisson Gallery, London

Kircher's Actor, 2000
Acrylic on paper
30 × 22 inches, 76 × 56 cm
Lehmann Maupin Gallery, New York

17
Click (Shutter), 1998
Acrylic on paper
30 × 22 inches, 76 × 56 cm
Lehmann Maupin Gallery, New York

Gothic (sic), 2001
Acrylic on paper
30 × 22 inches, 76 × 56 cm
Lehmann Maupin Gallery, New York

18
Actions Speak Louder than Images, 1997
Mixed media video installation
Lisson Gallery, London

19
Pickup, 2002
Acrylic on paper
17 × 14 inches, 43.2 × 35.6 cm
Lehmann Maupin Gallery, New York

20
Tracer, 2001–2002
Acrylic on paper
30 × 22 inches, 76 × 56 cm
Lehmann Maupin Gallery, New York

Cult Recorder, 2002
Acrylic on paper
30 × 22 inches, 76 × 56 cm
Lehmann Maupin Gallery, New York

21
Confusion F/X, 2000
Acrylic on paper
30 × 22 inches, 76 × 56 cm
Lehmann Maupin Gallery, New York

Fairy Man, 2001
Acrylic on paper
30 × 22 inches, 76 × 56 cm
Lehmann Maupin Gallery, New York

22
What You Can't See (B/W), 2000
Acrylic on paper
30 × 22 inches, 76 × 56 cm
Lehmann Maupin Gallery, New York

What You Can't See (In Color), 2000
Acrylic on paper
30 × 22 inches, 76 × 56 cm
Lehmann Maupin Gallery, New York

23
Pokémon Photic Seizures, 1998
Acrylic on paper
30 × 22 inches, 76 × 56 cm
Lehmann Maupin Gallery, New York

24
Bad Doll, 2001
Acrylic on paper
14 × 11 inches, 35.6 × 27.9 cm
Private collection, New York

Still Lives and Skulls, 1998
Installation view
Metro Pictures, New York

25
Untitled (Skull with Butterflies), 1999
Acrylic on paper
30 × 22 inches, 76 × 56 cm
Private collection, New York

26
Crystalizeding, 2002
Acrylic on paper
30 × 22 inches, 76 × 56 cm
Lehmann Maupin Gallery, New York

27
Slang, 2000
Acrylic on paper
30 × 22 inches, 76 × 56 cm
Private collection, New York

28
The Influence Machine, 2000–2002
Outdoor video installation
Madison Square Park, New York; Soho Square,
London; Magasin 3, Stockholm
Produced by Public Art Fund (New York) and
Artangel (London)

31
Let's Switch, 1996
Cloth, fiberglass, video projector, video tape
Dimensions variable
Private collection

Barbara Kruger, *Untitled (You Are Not Yourself)*, 1982
Black and white photograph
69 ¾ × 47 ½ inches, 175 × 120 cm
The Flick Collection, Berlin
Courtesy Galerie Hauser & Wirth, Zurich

32
Gold Walk, 2005
Acrylic and collage on paper
17 × 14 inches, 43.2 × 35.6 cm
Lehmann Maupin Gallery, New York

Alexei Jawlenski, *Abstract Head: Life and Death*, 1923
Oil and pencil on cardboard
16 ¾ × 12 ⅞ inches, 42.5 × 32.7 cm
Norton Simon Museum, The Blue Four Galka
Collection

35
Composite Still-Life, 1999
Fiberglass, video projector, video tape
Metro Pictures, New York

Philippe Halsman (in collaboration with Salvador
Dalì), *In voluptas mors*, 1951
Black and white photograph

36
Crystalizeding, 2002
Acrylic on paper
30 × 22 inches, 76 × 56 cm
Lehmann Maupin Gallery, New York

Andy Warhol, *Skull*, 1976
Silkscreen ink and synthetic polymer paint
on canvas, 15 × 19 inches, 38 × 48.3 cm
Courtesy The Andy Warhol Foundation

37
The Influence Machine, 2000–2002
Outdoor video installation
Madison Square Park, New York; Soho Square,
London; Magasin 3, Stockholm
Produced by Public Art Fund (New York) and
Artangel (London)

Odilon Redon, *Strange Flower (Little Sister
of the Poor)*, 1880
Charcoal, black chalk, and black Conté crayon on
paper
16 × 13 inches, 40.4 × 33.2 cm
David Adler Collection, The Art Institute of
Chicago

Confusion F/X, 2000
Acrylic on paper
30 × 22 inches, 76 × 56 cm
Lehmann Maupin Gallery, New York

Odilon Redon, *Satan dominant le monde (Devil)*, 1877
Charcoal, chalk, and crayon on paper
17 × 12 inches, 43.2 × 35 cm
Private collection

38
Colost, 2004
Acrylic and collage on paper
28 ½ × 22 ½ inches, 72.4 × 57.2 cm
Lehmann Maupin Gallery, New York

Mikhail Larionov/Natalya Goncharova, *Drama in
Cabaret 13*, 1914
Filmstill

39
Untitled, 2003
Acrylic, graphite, and ballpoint pen
13 ⅝ × 11 inches, 34 × 27.9 cm
Metro Pictures, New York
Private collection, New York

Mike Kelley, *Cry Baby (from Monkey Island)*, 1983
Acrylic on paper
29 ½ × 69 inches, 75 × 175 cm
Courtesy the artist

40
Anti, 2002
Acrylic on paper
24 × 19 inches, 61 × 48.3 cm
Lehmann Maupin Gallery, New York

Suzanne Duchamp, *Radiation de deux seuls éloignés*,
1916/1918/1920
Watercolor and collage on paper
8 ¼ × 11 ½ inches, 21 × 29.6 cm
Private collection

41
Unkie, 2002–2003
Acrylic on paper
30 × 22 inches, 76 × 56 cm
Lehmann Maupin Gallery, New York

Fernand Léger, *Nature morte (Les clés)*, 1928
Oil on canvas
25 ½ × 21 ¼ inches, 65 × 54 cm
Tate Modern, London

43
Cyc, 2003
Aqua-Resin, video
Metro Pictures, New York

43
Joan Miro, *Person Throwing a Stone at a Bird*, 1926
Oil on canvas
29 × 36 ¼ inches, 73.7 × 92.1 cm
MOMA, New York

Handsome, 2003
Acrylic on paper
30 × 22 inches, 76 × 56 cm
Lehmann Maupin Gallery, New York

Emil Nolde, *Masks*, 1911
Oil on canvas
28 ¾ × 30 ½ inches, 73 × 77.5 cm
The Nelson-Atkins Museum of Art, Kansas City

49
Tune Mort, 2003
Acrylic on paper
30 × 22 inches, 76 × 56 cm
Lehmann Maupin Gallery, New York

50
TV-Studio, 2002
Installation view
Station, Magasin 3, Stockholm

51
Nordic Test, 2002
Acrylic on paper
30 × 22 inches, 76 × 56 cm
Magasin 3, Stockholm

52
Frequency Spectrum, 2002
Wood, paint
78 ¾ × 94 ½ × 44 ½ inches, 200 × 240 × 113 cm
Station, Magasin 3, Stockholm

53
Freqlot 2, 2002
Acrylic on panel
24 × 19 inches, 61 × 48.3 cm
Lehmann Maupin Gallery, New York

54
Cyc, 2003
Aqua-Resin, video
Metro Pictures, New York

Oh TV!, 2003
Acrylic on paper
30 × 22 inches, 76 × 56 cm
Lehmann Maupin Gallery, New York

55
Handsome, 2003
Acrylic on paper
30 × 22 inches, 76 × 56 cm
Lehmann Maupin Gallery, New York

Visitation, 2003
Acrylic on canvas
30 × 24 inches, 76 × 61 cm
Lehmann Maupin Gallery, New York

Untitled, 2003
Acrylic on canvas
30 × 24 inches, 76 × 61 cm
Lehmann Maupin Gallery, New York

56
Baird vs Future, 2004
Acrylic on paper
28 ¾ × 23 inches, 73 × 58.5 cm
Lehmann Maupin Gallery, New York

Reptamation, 2003
Acrylic on canvas
30 × 24 inches, 76.2 × 61 cm
Lehmann Maupin Gallery, New York

57
Over & Out (Blue), 2003
Acrylic on paper
30 × 22 inches, 76 × 56 cm
Lehmann Maupin Gallery, New York

Neg Leg, 2003
Acrylic on paper
30 × 22 inches, 76 × 56 cm
Lehmann Maupin Gallery, New York

58
Chine. 2003
Acrylic on paper
30 × 22 inches, 76 × 56 cm
Lehmann Maupin Gallery, New York

59
Dough Boy, 2004
Acrylic on paper
30 × 22 inches, 76 × 56 cm
Lehmann Maupin Gallery, New York

60
Untitled Remote with Doll
Acrylic on paper
30 × 22 inches, 76 × 56 cm
Lehmann Maupin Gallery, New York

Compression, 2002
Plexiglas, Sony VPL-CS4 projector, metal
37 × 18 × 16 inches, 94 × 46 × 41 cm
Performance by Tony Oursler

61
Untitled, 1999
Acrylic on paper
30 × 22 inches, 76 × 56 cm
Lehmann Maupin Gallery, New York

Unkie, 2002–2003
Acrylic on paper
30 × 22 inches, 76 × 56 cm
Lehmann Maupin Gallery, New York

62
Pattern America, 1998
Acrylic and marker on paper
30 × 22 inches, 76 × 56 cm
Lehmann Maupin Gallery, New York

63
Redskull Experiment, 1999
Mixed media on paper
30 × 22 inches, 76 × 56 cm
Lehmann Maupin Gallery, New York

65
Video production still, 2005

66
Silv, 2004
Acrylic and collage on paper
28 ½ × 22 ½ inches, 72.4 × 57.2 cm
Lehmann Maupin Gallery, New York

Twiced, 2004
Acrylic and collage on paper
28 ½ × 22 ½ inches, 72.4 × 57.2 cm
Private collection, Madrid

67
Non, 2004
Acrylic and collage on paper
28 ½ × 22 ½ inches, 72.4 × 57.2 cm
Lehmann Maupin Gallery, New York

68
Metalla, 2004
Acrylic and collage on paper
28 ½ × 22 ½ inches, 72.4 × 57.2 cm
Lehmann Maupin Gallery, New York

69
Spectra, 2004
Acrylic and collage on paper
28 ½ × 22 ½ inches, 72.4 × 57.2 cm
Private collection, Madrid

70
Gold Walk, 2005
Acrylic and collage on paper
17 × 14 inches, 43.2 × 35.6 cm
Lehmann Maupin Gallery, New York

Climaxed, 2005
Video Installation, Aqua-Resin
Metropolitan Museum of Art, New York

71
Crimsac, 2004
Acrylic and collage on paper
28 ½ × 22 ½ inches, 72.4 × 57.2 cm
Lehmann Maupin Gallery, New York

72
Goody, 2004
Aqua-Resin, video, metal
24 × 10 × 48 inches, 61 × 25.4 × 122 cm
Galleria Soledad Lorenzo, Madrid

73
Colost, 2004
Acrylic and collage on paper
28 ½ × 22 ½ inches, 72.4 × 57.2 cm
Lehmann Maupin Gallery, New York

74
Ogled, 2004
Acrylic and collage on paper
28 ½ × 22 ½ inches, 72.4 × 57.2 cm
Lehmann Maupin Gallery, New York

75
Cla, 2004
Acrylic and collage on paper
28 ½ × 22 ½ inches, 72.4 × 57.2 cm
Lehmann Maupin Gallery, New York

76
Production still for *Bell Deep*, 2005

Untitled, 2003
Acrylic and collage on paper
30 × 22 inches, 76 × 56 cm
Lehmann Maupin Gallery, New York

77
Untitled, 2003
Acrylic, graphite, and ballpoint pen
13 ⅝ × 11 inches, 34.3 × 28 cm
Metro Pictures, New York
Private collection, New York

81
Closet Painting (Pepto-Bismol), 1992
Watercolor on paper
9 × 12 inches, 22.9 × 35 cm
private collection

Fantastic Prayer, 2000
With Constance DeJong and Stephen Vittiello
CD-Rom

84
Flucht, 2001
Video and sound installation
Kunsthaus Bregenz

The Influence Machine, 2002
Outdoor video installation
Magasin 3, Stockholm
Produced by Public Art Fund (New York) and
Artangel (London)

Million Colors, 2006
Video installation
Arcade of the Phoenix Civic Plaza
Phoenix, Arizona

91
Polymorph-Green, 2004
Acrylic and collage on panel
45 × 44 1/2 inches, 114.3 × 113 cm
Private collection, Belgium

92
(clockwise)

Polymorph-Polychrome, 2004
Acrylic and collage on panel
45 × 45 inches, 114.3 × 114.3 cm
Private collection, New York

Ether, 2006
Aluminum, acrylic, glitter, LCD screen, DVD player
46 × 42 inches, 116.8 × 106.7 cm
Private collection, Monaco

Eclipse, 2004
Acrylic and collage on panel
47 × 72 inches, 119.4 × 182.9 cm
Private collection, New York

93
Purplite, 2005
Aqua-Resin, video
50 × 64 × 22 inches, 127 × 162.5 × 56 cm
Galeria Soledad Lorenzo, Madrid

94
(clockwise)

Splotch, 2004
LCD screen, DVD and DVD player, aluminum
and acrylic
37 × 45 × 4 inches, 94 × 114 × 11 cm
Galeria Soledad Lorenzo, Madrid

Digo, 2004
LCD screen, DVD and DVD player, aluminum
and acrylic
33 × 37 × 4 inches, 84 × 94 × 11 cm
Galeria Soledad Lorenzo, Madrid

Daub, 2004
LCD screen, DVD and DVD player, aluminum
and acrylic
40 × 40 × 4 inches, 101 × 101 × 11 cm
Galeria Soledad Lorenzo, Madrid

95
Ruby, 2004
LCD screen, DVD and DVD player, aluminum
and acrylic
36 × 36 × 4 inches, 91 × 91 × 11 cm
Galeria Soledad Lorenzo, Madrid

96
Cowel, 2006
Collage and mixed media on paper
23 1/2 × 17 1/2 inches, 60 × 45 cm
Bernier/Eliades Gallery, Athens

97
Balls, 2006
Collage and mixed media on paper
23 1/2 × 17 1/2 inches, 60 × 45 cm
Bernier/Eliades Gallery, Athens
Private collection, Switzerland

98
Spaced, 2007
Aqua-Resin
50 × 67 × 26 inches, 127 × 170 × 66 cm
Margo Leavin Gallery, Los Angeles

Have a Nice Day, 2006
Collage and mixed media on paper
23 1/2 × 17 1/2 inches, 60 × 45 cm
Bernier/Eliades Gallery, Athens
Private collection, Athens

99
Diamond Ascension, 2006
Collage and mixed media on paper
23 1/2 × 17 1/2 inches, 60 × 45 cm
Bernier/Eliades Gallery, Athens
Private collection, Athens

100
Smoke Snake, 2006
Carbon on wood panel, video monitor, DVD player
40 × 30 inches, 101.6 × 76 cm
Lehmann Maupin Gallery, New York

Moon?, 2007
Acrylic and collage on paper
24 × 19 inches, 61 × 48 cm
Lehmann Maupin Gallery, New York

101
Smoke, 2005
Collage and carbon on paper
14 × 10.5 inches, 35.6 × 26.7 cm
Lehmann Maupin Gallery, New York

102
Diamond Dust, 2003
Acrylic and glitter with collage on paper
14 × 11 inches, 35.6 × 27.9 cm
Lehmann Maupin Gallery, New York

103
Dust, 2006
Aqua-Resin and video installation
Metro Pictures, New York

105
Red "Love Hurts" Laboratory, 2007
Aluminum, acrylic, LCD screen, DVD player
58 × 47 × 4 1/2 inches, 147.3 × 119.4 × 11.4 cm
Private collection, Belgium

106–107
Blackisblackerthanblack, 2007
Aluminum, acrylic, LCD screen, DVD player
47 1/2 × 94 × 4 1/2 inches, 120.7 × 238.8 × 11.4 cm
Lehmann Maupin Gallery, New York

108
Video stills from *Purple Ideation Exposure*, 2007
Installation view, Lehmann-Maupin Gallery
New York, 2007

109
Purple Ideation Exposure, 2007
Aluminum, acrylic, LCD screen, DVD player
59 × 47 × 4 1/2 inches, 149.9 × 119.4 × 11.4 cm
Private collection, New York

110
Invisible Green Link?, 2007
Aluminum, acrylic, LCD screen, DVD player
59 × 47 × 4 1/2 inches, 149.9 × 119.4 × 11.4 cm
Lehmann Maupin Gallery, New York

111
Braincast, 2004
Video installation
Seattle Public Library

112
wadcutter-semiwadcutter-I'm-OK-slug, 2007
Aqua-Resin, video
Galleria Emi Fontana, Milan

113
Epistemological Nine, 2007
Inkjet print
40 × 28 inches, 101.6 × 71.1 cm
Galleria Emi Fontana, Milan

114
(clockwise)

Untitled Project for Land and Beach, 2008
Video projections
Gibbs Farm, New Zealand

Sad Genealogy, 2008
Mixed media on paper
24 × 19 inches, 61 × 48.3 cm
Lehmann Maupin Gallery, New York

Untitled Project for Land and Beach, 2008
Storyboard, video stills
Gibbs Farm, New Zealand

115
Mostly Negative, 2008
Mixed media on paper
24 × 19 inches, 61 × 48.3 cm
Lehmann Maupin Gallery, New York

116
One Shot Roulette, 2008
Mixed media on paper
24 × 19 inches, 61 × 48.3 cm
Private collection, France

117
Scared to Death, 2008
Mixed media on paper
24 × 19 inches, 61 × 48.3 cm
Lehmann Maupin Gallery, New York

Mask/No Mask, 2008
Mixed media on paper
24 × 19 inches, 61 × 48.3 cm
Lehmann Maupin Gallery, New York

118
Random Configuration, 2008
Mixed media on paper
24 × 19 inches, 61 × 48.3 cm
Lehmann Maupin Gallery, New York

144
The Influence Machine, 2000–2002
Outdoor video installation
Madison Square Park, New York
Produced by Public Art Fund (New York) and
Artangel (London)

Biography

Tony Oursler was born in 1957 in New York, where he lives and works. He attended the California Institute for the Arts and graduated in 1979.

His work has been widely exhibited in international institutions such as the Centre Georges Pompidou, Paris (1986); the Museum für Gegenwartskunst, Basel (1989); the Ikon Gallery, Brimingham (1993); Kunstwerke, Berlin (1993); the Secession, Vienna (1995); Portikus, Frankfurt (1995); the Van Abbemuseum, Eindhoven (1995); the Museum of Contemporary Art, San Diego (1996); the ICA Philadelphia (1997); the Malmö Konsthall (1998); the Hirshhorn Museum, Washington (1998); the MASSMOCA, N. Adams (1999); the LACMA, Los Angeles (1999); the Whitney Museum, New York (2000); the Kunsthaus Bregenz (2001); Magasin 3, Stockholm (2002); as well at the Jeu de Paume, Paris (2005). He was also participating to various festivals and Biennales from the 1980s, including Documenta X in 1997, as well as numerous group shows.

An updated bio- bibliography is available at www.tonyoursler.com.

Edited by
Lionel Bovier, Mariska Nietzman, Tony Oursler

Editorial Coordination
Mariska Nietzman, Kevin Slide, Stephanie Smith

Editing and Proofreading
Clare Manchester

Iconography Research
Salome Schnetz

Design
Gavillet & Rust / Eigenheer

Cover
Metalla, 2004
Acrylic and collage on paper
28 ½ × 22 ½ inches, 72.4 × 57.2 cm
Lehmann Maupin Gallery, New York

Photo Credits
Geoffrey Clements, Staten Island, NY (p. 40);
Stefan Hagan (p. 77); Boris Kirpotin (p. 96, 97,
98, 99); KUB/S.F.&H. Bregenz (p. 80)

Colour Separation & Print
Musumeci S.p.A., Quart (Aosta)

Typeface
Janson

Printed in Europe

Published by
JRP|Ringier
Letzigraben 134
CH–8047 Zurich
T +41 (0) 43 311 27 50
F +41 (0) 43 311 27 51
info@jrp-ringier.com
www.jrp-ringier.com

In collaboration with
Lehmann Maupin Gallery, New York
540 West 26th Street (NY 10001)
201 Chrystie Street (NY 10002)
T 212 255 2923 | 212 254 0054
F 212 255 2924 | 212 254 0055
E info@lehmannmaupin.com
www.lehmannmaupin.com

ISBN 978-3-905829-25-9

JRP|Ringier books are available internationally
at selected bookstores and from the following
distribution partners:

Switzerland
Buch 2000, AVA Verlagsauslieferung AG,
Centralweg 16, CH–8910 Affoltern a.A.,
buch2000@ava.ch, www.ava.ch

France
Les Presses du réel, 16 rue Quentin, F–21000
Dijon, info@lespressesdureel.com,
www.lespressesdureel.com

Germany and Austria
Vice Versa Vertrieb, Immanuelkirchstrasse 12,
D–10405 Berlin, info@vice-versa-vertrieb.de,
www.vice-versa-vertrieb.de

UK and other European countries
Cornerhouse Publications, 70 Oxford Street,
UK–Manchester M1 5NH, publications
@cornerhouse.org, www.cornerhouse.org/books

USA, Canada, Asia, and Australia
D.A.P./Distributed Art Publishers, 155 Sixth
Avenue, 2nd Floor, USA–New York, NY 10013,
dap@dapinc.com, www.artbook.com

For a list of our partner bookshops or for any
general questions, please contact JRP|Ringier
directly at info@jrp-ringier.com, or visit our
homepage www.jrp-ringier.com for further
information about our program.

143

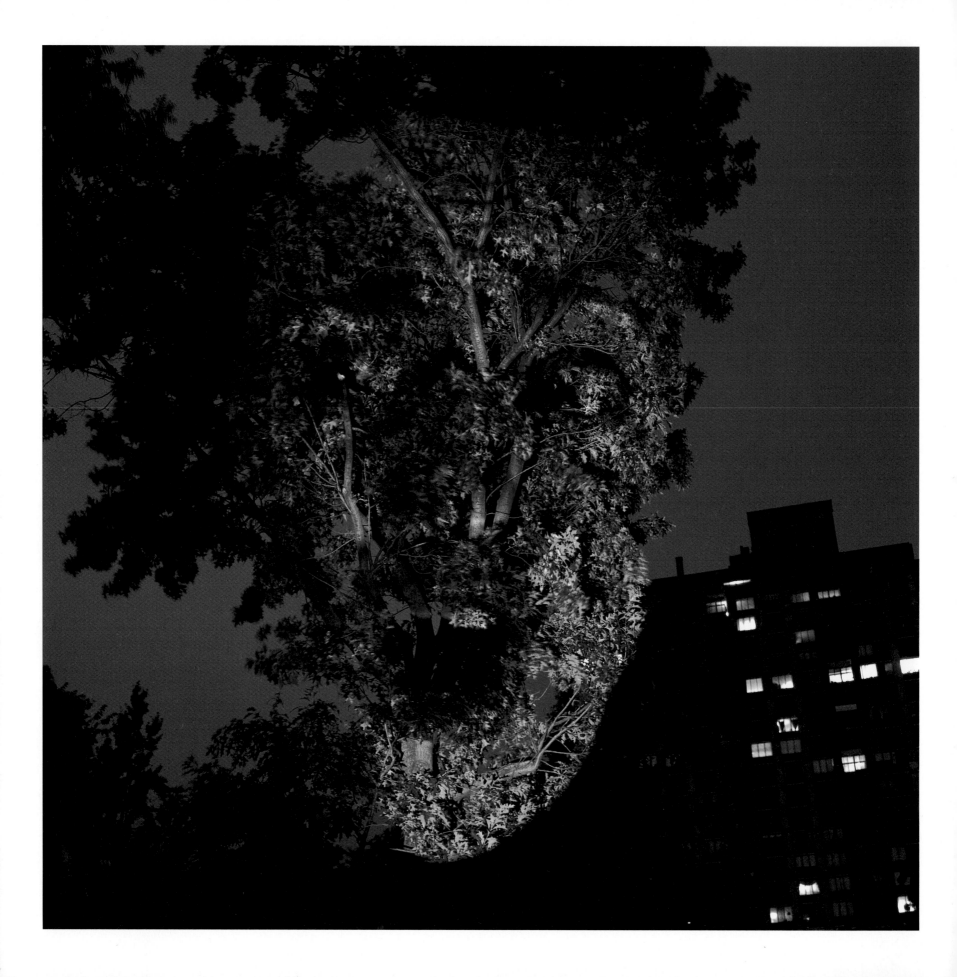